ART ANSWERS

Drawing and SKETCHING

EXPERT ANSWERS
TO THE QUESTIONS
EVERY ARTIST ASKS

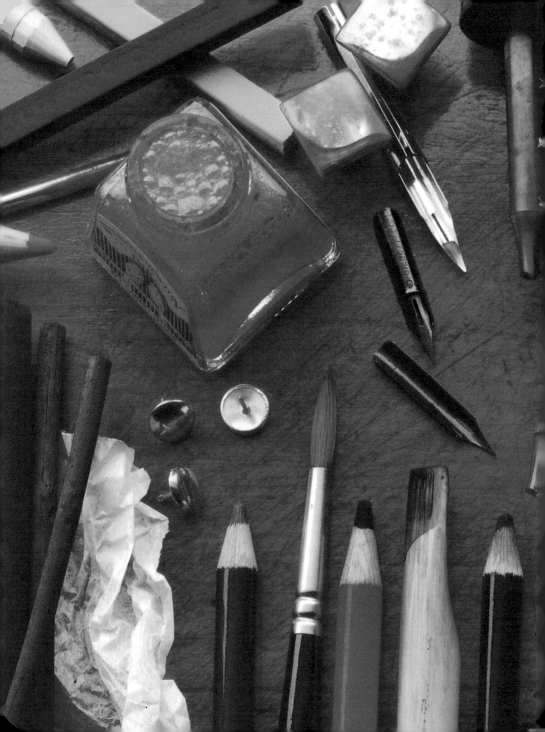

ART
ANSWERS

Drawing and SKETCHING

EXPERT ANSWERS
TO THE QUESTIONS
EVERY ARTIST ASKS

VERA CURNOW

BARRON'S

A Quantum Book

Copyright © 2012 Quantum Publishing

First edition for North America and the Philippines published in 2012 by
Barron's Educational Series, Inc.

All inquiries should be addressed to:
Barron's Educational Series, Inc.
250 Wireless Boulevard
Hauppauge, New York 11788
www.barronseduc.com

ISBN: 978-1-4380-0125-8

Library of Congress Control Number: 2011942874

This book is published and produced by
Quantum Books
6 Blundell Street
London N7 9BH

QUMAADA

Publisher: Sarah Bloxham
Managing Editor: Jennifer Eiss
Consultant Editor: Vera Curnow
Editor: Freya Dangerfield
Project Editor: Samantha Warrington
Assistant Editor: Jo Morley
Design: Sarah Underhill
Production Manager: Rohana Yusof

Printed in China by Midas Printing International Ltd.

9 8 7 6 5 4 3 2 1

Contents

Introduction

BY VERA CURNOW

It began with stories on walls … those pictorial scrawls on cave walls that chronicled everything from simple sightings to visual narratives of the day's events. When you consider the naiveté of the cave dweller who was not even making tools, it seems truly amazing that this semi-erect Neanderthal would think to depict images to create a visual diary of the world around him using the earth's elements. It is apparent that drawing is innate in human nature.

It is often a great surprise to discover for the first time the range of images and techniques to be found in the history of the art of drawing. The dictionary definition for the word *drawing* is far too narrow to be of any real value in understanding the breadth of work that an art historian would include in the category of drawn images. However, many people still think that drawing is done only with a pencil and consists mainly of outlines.

This book will demonstrate that drawing is not about the tools, methods, or media that you use. It is about "seeing" to translate the three-dimensional into two-dimensional form. As you begin to work, strive to create a representational drawing; this will hone your drawing skills and help you develop your hand-and-eye coordination. Once you have developed your basic drawing skills, you are ready to experiment and diversify.

The premise of this book is that anyone can learn to draw; the bottom line is that drawing is learned by simply doing it. The key to improving your skills is to draw on a regular basis. Whatever your results, remember to embrace the process – it is an ongoing journey …

Enjoy!

Vera

Vera Curnow

Above: *I had this dream about you,* Vera Curnow, colored pencil *This drawing was a composite of many images using reference materials. The artist began by creating a small 5 x 7in (13 x 18cm) collage and then used it to create an enlarged drawing measuring 20 x 15in (51 x 38cm).*

1

MEDIA AND APPLICATION TECHNIQUES

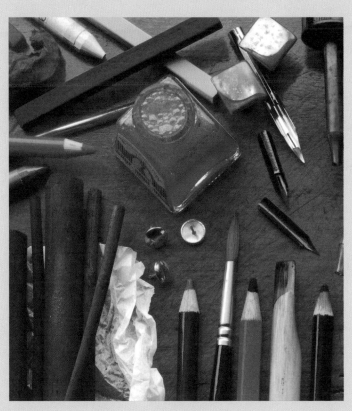

How do I use a graphite pencil?

A graphite pencil can be used in a variety of ways but is most commonly used for making a line; the result is a crisp, clear drawing. Shadow can be produced by hatching or crosshatching, which is a set of parallel lines or two opposing sets of parallel lines, respectively; alternatively, the pencil can be used to softly shade an area. The softer varieties of pencil can produce very soft areas of tone when blended with a finger or torchon (see page 16), or by spreading with an eraser. The flexibility of this medium allows for much variation and experimentation.

Different combinations of pencil and paper produce a wide range of effects. Here a 2B pencil has been used.

A soft pencil (4B) creates a graduated tone on a moderately soft paper.

Used on a rough paper, this same 4B pencil gives a much less even result.

Achieve this effect by drawing with the reverse end of the pencil to create indentations, then shading over.

An eraser is a useful tool to use with a pencil drawing when specific effects are required. Here 2B lines have been partially erased.

A series of lines drawn with pencils ranging from 6H to 6B shows the differences in the weight that can be achieved.

For a very strong, dramatic effect use carbon paper on top of your drawing surface.

Here, tone has been blocked in using a 2B pencil.

What do the letter and number on graphite pencils mean?

Pencils are graded by the *H* and *B* letter systems. H through to 8H indicate increasing hardness of lead, whereas B to 8B denote increasingly soft cores. It is important to experiment with a wide range of pencils, as their characteristics may vary according to the paper used: a hard pencil, for example, makes a fainter mark on a smooth, coated paper than on a coarsely textured one. Similarly, a very soft pencil will make an intensely dark, coarse, and rich line on textured paper, so that marks may prove difficult to control. Varying the pressure in which you apply the pencil will also help to create a range of marks and tonal values.

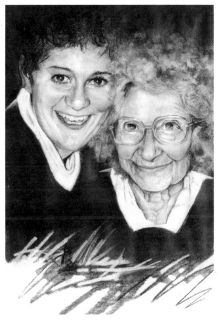

Above: *Mother and daughter*, Vera Curnow, pencil *In this drawing a variety of pencil grades were used to capture the various tonal values. The lightest grades established the skin tones and gray hair; the middle grades developed the shadows in the gray hair and faces; and the darkest (softest) pencil grade was used for the clothing and background. The lightest highlights seen in the drawing are simply untouched areas of white paper.*

Above: *Pencils are the least expensive of all the artist's tools, so you can afford to start with a good selection, ranging from HB to 4B or even 6B.*

ARTIST'S TIP

Often the best way to exploit the pencil fully is to combine several different grades.

Is it possible to work with just one pencil grade?

Definitely: Most artists spend much time working with just one medium-soft pencil – grade 2B or 3B – as these can render most of the tones required. However, harder pencils are sometimes very useful when trying to draw a structure or architectural details. A wide variety of tones can be achieved with the sensitive adjustment of touch, marks, and shading available from a single pencil, and with the use of an eraser to expose the paper's white surface. Find a viewpoint providing an interesting blend of light and dark features to create a lively and contrasting scene with just one pencil, as demonstrated here.

Technique study: Working with a 2B pencil

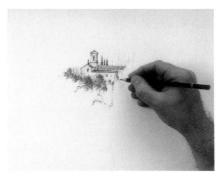

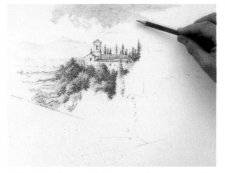

1 Starting from the center of focus – in this case the tower of a chapel among trees – outline the main areas with your 2B pencil. This needs little more than the line created by the weight of the pencil on the paper. As you work, emphasize these light touches when you are satisfied with their position.

2 Keeping the pencil sharp, work on some of the lighter areas, such as the sky. There is a surprising variety of tones here, too, and by using the side of the pencil you can create a contrast with the foliage. The trees can be created from a series of small marks, rather than by shading.

ARTIST'S TIP

To keep your pencil sharp, turn it in your hand every few minutes to maintain the point.

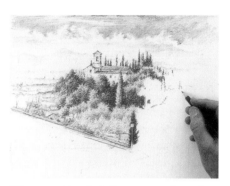

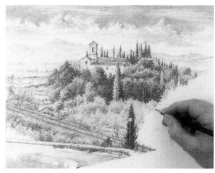

3 The central band of olive trees requires soft marks to make it stand out against the darker trees behind. At this point the hills are lightly shaded in the background.

4 Pick out the darker tones around the clouds in the sky with soft shading that leaves no sign of individual pencil marks. If you are right-handed, you will find that working across the paper from left to right will help to prevent smudging with the back of the hand – and vice versa for left-handed artists.

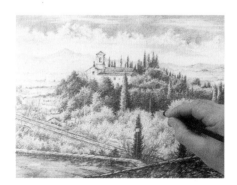

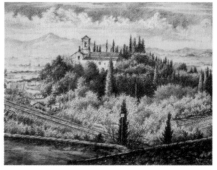

5 A shadowed foreground with little to offer in terms of details can take broader, denser strokes of the pencil, thus highlighting the lighter elements that surround it. A variety of marks prevent the drawing from becoming lifeless or too one-paced.

6 Soften the sky slightly with an eraser, and give some form to the hills on the left by rubbing back to the paper surface. Check for consistency in the way the light and shadows fall. You can now commit yourself fully to darkening shadowed areas with firm marks, to create a consistent whole.

Does graphite come in other forms besides the pencil?

Yes, it does. A useful alternative to the ordinary pencil, particularly for quick outdoor drawing, is the propelling clutch pencil, for which the lead is purchased separately. This is particularly useful in that no sharpening is required and a fine line can be continuously maintained. The solid graphite stick, normally graded at approximately 3B, is also very useful for laying down large areas of shade in larger, tonal pencil drawings, and is often used in conjunction with a regular pencil.

In addition, a number of artists draw with raw graphite powder, rubbing it into the paper to make large tonal marks, then bringing out highlights with an eraser and more detailed areas with a regular pencil. This method is suitable for very large works. Graphite powder can be made by scraping down a graphite stick with a sharp knife. Applying the powder with a torchon, a pencil-shaped tool of rolled soft paper, produces a subtle mark that you can use in preference to rubbing with a finger, which tends to make an unspecified, vague mark.

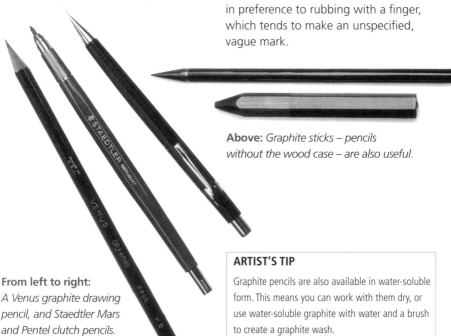

Above: *Graphite sticks – pencils without the wood case – are also useful.*

From left to right:
A Venus graphite drawing pencil, and Staedtler Mars and Pentel clutch pencils.

ARTIST'S TIP

Graphite pencils are also available in water-soluble form. This means you can work with them dry, or use water-soluble graphite with water and a brush to create a graphite wash.

What types of erasers work best with graphite pencils?

There is a large assortment of erasers available for use with graphite pencils. A kneadable putty eraser is very gentle and will not alter your drawing surface – it is therefore best for lifting graphite from your work and can also be used to lighten areas that may be too dark by gently rubbing. Gum erasers have a cleaning agent in them and are good for cleaning up large areas of graphite.

Pencil and graphite marks can be erased using a firm white plastic eraser, but avoid gritty types that abrade the drawing surface. Rubber erasers (usually pink) should be used with care, as some brands will leave a pink stain on your paper. Soft vinyl erasers are best for fragile surfaces. It is always wise to test any eraser on scrap paper to make sure it is not abrasive and therefore will not damage your working surface.

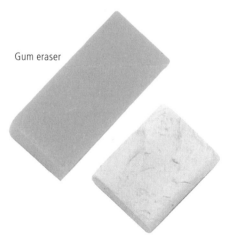

Gum eraser

Kneadable putty eraser

Above: *Use a plastic eraser to remove unwanted graphite marks after making alterations. This cleans the paper efficiently without abrasion and reduces smearing, which occurs if gritty or tacky erasers are used. When the end of an eraser becomes rounded with wear, use a craft knife to trim a sharp edge for precise work.*

ARTIST'S TIP

When you have finished a drawing in soft grades of pencil, fix it lightly or it may rub in exposed areas, particularly in a sketchbook, which may get carried around frequently.

Using a torchon

A torchon, manufactured from soft paper rolled into a cone shape, is the best tool for softening drawing marks in soft media. Small torchons have long points, and large types are firmer and double-ended. A torchon coated in graphite can be used to draw fine, delicate marks. Clean torchons with a plastic eraser, or a kneadable putty eraser when you use it with charcoal or soft pastels.

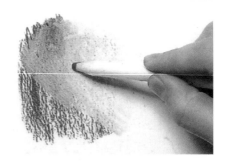

Above: *A torchon gives you a clear view and more control than your fingertip.*

What are the characteristics of colored pencils?

Colored pencils are probably the color drawing medium with which you will be the most familiar. These pencils, which are thin sticks of color encased in wood, vary in softness depending on the type. Some are relatively hard, and can be sharpened so that they will make very incisive lines. Others are softer and more like pastels to use, except that they are much more manageable.

Colored pencils have a core of pigment with a slightly waxy texture that gives the paper a surface sheen when it is densely covered. Firm drawing creates strong, bright colors, but start by making faint marks; although a kneadable putty eraser will remove most of the pigment, the wax makes it difficult to erase colored pencils without any trace.

With colored pencils the colors can be mixed to some extent by laying one over another (see page 20), but a wide range of ready-mixed colors is available. To start drawing with colored pencils you will need two reds (one crimson), a blue, a yellow, a green, and black. You could also buy a box of assorted colors – a range of twelve or eighteen pencils is the ideal quantity with which to start because it will force you to experiment with color mixing.

Below left, and right: *Colored pencils are made in a very wide color range. They are sold in sets or individually, and vary in consistency from one make to another.*

ARTIST'S TIP

Colored pencils, being easy to handle as well as light and portable, are an excellent medium for rapid drawings and outdoor sketches.

What surfaces work well with colored pencils?

The possibilities for surfaces on which to work with colored pencils are endless. Any surface on which you can leave a mark can be used – from slick and textured surfaces to colored papers. However, you should try to use quality artist grades that are acid-free; some excellent papers on which to work with this medium are Stonehenge, Strathmore Museum, and Canson. Some artists like to work on sturdier surfaces like

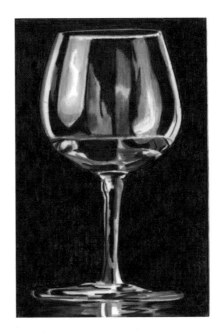

Right: *Wine glass,* **Vera Curnow, colored pencil** *This drawing was done on a two-sided, matte drafting film. The matte finish allows you to work on both sides of the film.*

hot- or cold-pressed illustration board as well as mat boards, which should also be available in your local art store. Some unconventional surfaces also used for colored pencil drawing are two-sided drafting film, fine-grade sanded pastel paper or board, suede, and even unfinished wood.

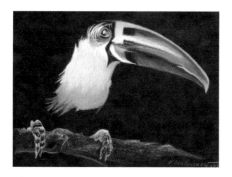

Above: *Toucan*, **Vera Curnow, colored pencil** *This colored pencil drawing was developed on black suede mat board; this surface should be available in many colors at your local framing store. Suede can withstand many layers of colored pencil application.*

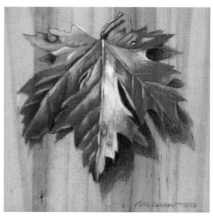

Above: *Autumn leaf*, **Vera Curnow, colored pencil** *When you work on wood, you do not need to prime or prep the surface in any way. This piece was completed on raw wood and then sprayed with a gloss fixative.*

Right: *The fiddler*, **Vera Curnow, colored pencil** *This was drawn on sanded 800-grit pastel paper. Because of its texture, this paper makes it difficult to achieve fine details and will "chew up" colored pencils quickly. You will therefore need to sharpen your pencils often.*

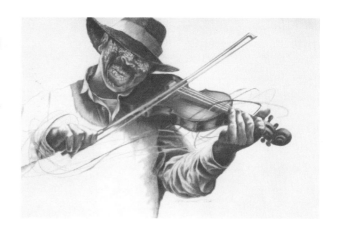

What kind of strokes are used to apply colored pencils?

There are many different ways to apply colored pencils – there is no right or wrong way. You can use circular, hatched, crosshatched, vertical, scumbled, tonal, or stippled applications (shown below) – or any combination of these. The effects you can obtain depend on several factors: the grade of the pencil (its hardness or softness), the pressure you exert, the speed of the line, the surface of the paper, and, last but not least, the way the pencil is held.

Right: John Townend, colored pencil *This lively and rapidly made location drawing was completed in colored pencil. Notice the variations in the direction of the lines, with diagonal marks used for the sky, vertical ones for the foreground field, and multidirectional ones suggesting the different growth patterns of the trees.*

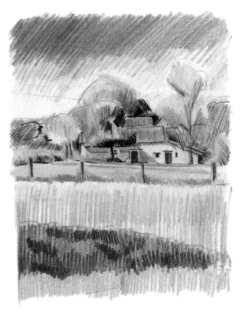

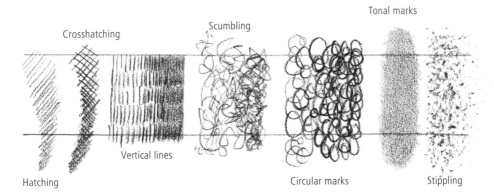

Crosshatching

Scumbling

Tonal marks

Hatching

Vertical lines

Circular marks

Stippling

How do I build up color with colored pencils?

Colored pencils can achieve highly detailed effects and rich blends of color and are made in a wide variety of shades for surface mixing. True blending – where the colors mix and create a new shade – is not possible in this dry medium, so in most colored pencil drawings, tones and colors are built up by various methods of overlaying, such as hatching, crosshatching, and shading.

Hatching and crosshatching are the application of directional strokes. These techniques have traditionally been· used to build up areas of tone in monochrome drawings, but they are equally effective with colored pencils for mixing colors. Shading describes the method where the pencil is used to build up tone using layers of hatching or other strokes; it can also be used for mixing and modifying colors. One layer of shading can be laid over another to achieve a softer effect than is attained by hatching.

Different results can be achieved by using the same group of colors in another sequence, so experiment to find out the best order in which to create a particular shade; note a stroke of each contributing color, and the order used, beside the final mixture on a shade card. Your color mixing will improve rapidly when you have examined all the possible combinations.

ARTIST'S TIP

You can mix colored pencils with graphite pencils; the two are natural partners.

Above: *The color swatches show a sequence of crosshatching in which only four colors – yellow, orange, red, and blue – are used. It is usual to build up color from the palest tone to the darkest, thereby allowing scope for adjustment before the color becomes too dark.*

Technique study: Hatching and crosshatching

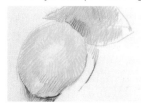
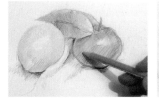
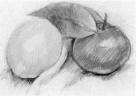

1 There is no rule about the direction of the crisscrossing lines; begin with roughly diagonal hatching lines and then overlay them with crosshatching.

2 Use further crosshatching to build up the forms and colors, increasing the pressure of the pencil where you want dense areas of color and decreasing the pressure where you want lighter areas.

3 Continue to apply crosshatching to complete the piece. The colors are rich, and the vigorous use of the pencils gives the drawing an attractive feeling of liveliness.

Technique study: Shading

1 Begin by drawing the outline and laying in the colors lightly, leaving certain areas of the paper white for the highlights.

2 Now add areas of dark shadow by gently shading; with this in place you will be better able to judge how much further shading is needed to build up the colors.

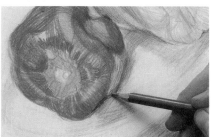

3 As when simply hatching and crosshatching, move the shading lines in any direction you choose. Here, follow the forms of the vegetables with your pencils.

4 In the final stages, build up the reds and greens more densely by further shading. In the highlight areas leave the paper uncovered or only very lightly covered, whereas in the areas of deepest color cover the paper completely.

What is impressing and how is it achieved?

Impressing is a pencil technique where the surface of the paper is indented with a tool. When color is applied on top, the pencil glides over the impressed lines so that they show through. It is best to use a fairly tough paper such as good-quality smooth watercolor paper, and to put another sheet of paper below to provide a yielding surface.

You can either draw "blind" directly on the paper with an implement such as a paintbrush handle or knitting needle, or use a tracing method. For an intricate design, draw it first on tracing paper, lay this on top of the working surface fixed with pieces of masking tape so that it does not slip, and then work over it with a hard pencil or ballpoint pen.

If your paper is white, the indentations will produce what is sometimes called a white line drawing, but the lines need not be white; you can also impress a design with the sharpened tip of a colored pencil or a graphite pencil, and work another color on top. Or you can lay down one layer of solid color before impressing, and work further layers on top.

Technique study: Impressing

1 Make the drawing, and then trace it. To create the finished piece, go over the traced lines firmly with a ballpoint pen.

2 Remove the tracing paper to reveal a faint indented image. The impressed lines will appear when you lay the colored pencil on top.

3 Glide the colored pencil over the impressed lines; these will emerge more strongly as more color is laid on.

4 Now add a second color, so the rim of the plate becomes visible. The drawing could be built up more, with further stages of impressing.

What is burnishing and how is it achieved?

This is a technique sometimes used in color pencil drawing to increase the brilliance of colors. After the color has been mixed on the paper, the surface is rubbed with a finger or a rag to produce a slight sheen. Metals, or surfaces covered with gold leaf, are often burnished to increase their luster, and the same principle is used in colored pencil drawing. The rubbing action sometimes smooths the grain of the paper, and it grinds down the colors and presses the particles of pigment into the paper, so that they blend together in a way that cannot be achieved by any other method of overlaying colors.

You can use a torchon, an eraser, or one of the pencils themselves for burnishing. Torchons and erasers are most suitable for soft, waxy pencils. Drawings in hard colored pencils are sometimes burnished with a white or pale gray pencil, using close shading with a firm pressure. This fuses the colors in the same way as a torchon or eraser, but the underlying colors will be modified by this form of burnishing. White pencil burnishing is a method well suited to drawing highlights on highly reflective surfaces. Burnishing is a slow process, and is often restricted to one area of a drawing.

Above: *These examples show the different effects that a variety of burnishing implements will achieve. Far left, the torchon offers a very controlled, highly pressured burnish, whereas the eraser, center, produces softer, smudged strokes. Right, the effect of a white pencil is seen most clearly where little or no paper shows through.*

ARTIST'S TIP

Be aware that this application can produce "wax bloom." This is a film that covers your drawing and is caused by the wax that rises to the top from all the heavy layers that were fused together. Do not be concerned, as it will disappear when you spray your work with fixative.

Technique study: Burnishing

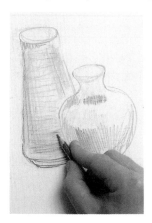

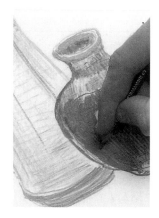

1 Burnishing is always a final stage in a drawing; first establish all the colors and build them up as thickly as desired using a combination of the shading and hatching techniques. Use curving lines on the body of the green vase to follow the contours.

2 Use a very dark blue pencil to press the color into the paper, creating a small area of dark reflection. On reflective surfaces, tonal changes are often very abrupt, with a distinct, hard-edged boundary between one tone and color and another.

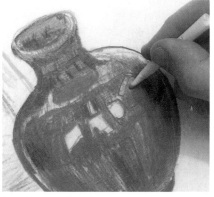

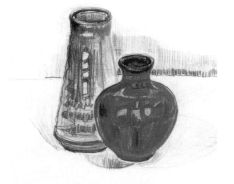

3 In this area, the colors merge more gently, so "push" the colors into one another and into the paper by rubbing with a torchon.

4 The contrast between the rich burnished colors and the sparkling highlights creates a convincing impression of the pot's shiny surface.

What is frottage and how is it achieved?

This is a method often used for building up areas of texture. The drawing paper is placed over some rough surface, such as heavily grained wood or coarse fabric, and rubbed with a soft pencil, colored pencil, conté crayon, or pastel stick so that it takes on the texture and pattern of the material below.

The technique has been used for brass rubbings for a long time, but its use in art was pioneered by the German Surrealist artist Max Ernst (1891–1976).

He is said to have conceived the idea when looking at some scrubbed floorboards, whose prominent grain stood out like the lines in a drawing.

Areas of frottage in a drawing can be used either suggestively or realistically. For example, you might simply want some irregular tone to enliven an area of your drawing, but if you were drawing a group of objects on a grainy wood table or against a textured wall, you could take rubbings of the actual texture.

Left: *The effects you achieve with this technique vary widely, as they are affected by both the thickness of the paper and the implement used for making the rubbing. Both these examples were made from the same object, a patterned tinfoil ornament. First colored pencil was used, on thin typing paper, and then conté crayon on heavy drawing paper.*

Left: *Wood grain is a popular subject for frottage; patterns and texture such as those shown here can easily be incorporated into a drawing. Both were made by placing paper on a pine kitchen table – a rougher surface would produce a more pronounced pattern. Hard pastel was used for the first rubbing, and soft (6B) pencil for the other.*

What are the advantages of charcoal?

The simple, burned twig of the charcoal used for drawing is produced by smoldering wood, usually willow but sometimes olive, slowly in reduced-oxygen conditions. The result is a stick charred to an even, sooty blackness that makes a smooth, rich drawing mark. It is a wonderfully versatile medium, and is often recommended by art teachers because it is less inhibiting than the pencil or pen, and therefore encourages a broad, free approach.

Charcoal has many advantages. Large areas of tone can be put in very rapidly, and the intensity can be altered by various methods. Because charcoal is a broader medium than pencil, it prevents over-elaboration of unneccesary detail. It is, however, sensitive and responsive to the slightest change in pressure, so you can produce a line that varies from the faintest possible tone to a deep, positive black. It can also be smudged to soften a line or tone, or lifted out with a kneadable putty eraser to create highlights or to correct mistakes.

There are, however, two distinct disadvantages to charcoal. When working out of doors, it is not unknown to have a drawing in an advanced state when a sudden gust of wind removes half your hard-won image before you have had time to apply a fixative. It is also quite a dirty medium. It is the vulnerability of the work while in progress that sometimes makes this not the most suitable medium for outdoor drawing for beginners.

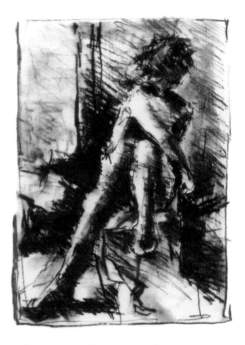

Above: Joan Elliott Bates, charcoal
Charcoal is the ideal medium for broad effects; here it has been used very freely to describe both the play of light on the figure and the dynamic qualities of the pose. Shading has been done by scribbling, hatching, and smudging, and the vigorous use of the medium gives the drawing life and vitality.

In what forms is charcoal available to artists?

Stick charcoal

Stick charcoal is usually sold in boxed bundles, and is graded fine, medium, and thick for width, and soft, medium, and hard for consistency. Block charcoal and scene painters' extra-large sticks are good for oversize work, but if you use the side as well as the tip, even small sticks create broad areas of tone. Do not be afraid to work boldly with this particular medium, because stick marks can be completely removed with a kneadable putty eraser.

Compressed charcoal

Compressed charcoal is put through a manufacturing process that compresses the carbon and makes it dense black, producing even-textured crayons. Kneadable putty erasers do not remove all of the surface material as they do with stick charcoal, so make delicate marks until you are sure of your layout. Compressed charcoal is also available mixed with chalk to make shades of gray; you can use white chalk to make your own mixtures. For pale shades, draw with chalk first and work the compressed charcoal into it gradually, as it is easy to over-darken.

Charcoal pencils

Charcoal pencils are a wood-cased, pencil version of compressed charcoal. They are often graded hard, medium, and soft, although some manufacturers adopt the same categories as graphite pencils. Charcoal pencil marks are erasable but traces remain, so start tentatively.

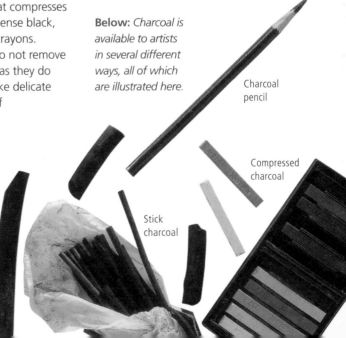

Below: *Charcoal is available to artists in several different ways, all of which are illustrated here.*

Charcoal pencil

Compressed charcoal

Stick charcoal

What are some basic techniques for applying charcoal?

Charcoal can be used lightly to produce delicate, spidery lines or with greater pressure to render darker, thicker ones. Note, for instance, the difference between pulling the charcoal down the paper and then pushing it up; you will find that pushing it gives a stronger line. Try pulling the stick across the paper horizontally. Then break off a short piece and use the side to make broad, chunky strokes. Experiment with different applications to build your repertoire with this medium.

Creating tone

It is easy – and very quick – to create areas of tone by simply using the side of the stick. You can also use hatching or crosshatching to build up areas of graded tone. If you want a flat, even mid-tone, you can rub the charcoal into the paper with your fingers. It can be darkened later with a further application. You may wish to fix the drawing from time to time if you want areas of very dark tone, or you could combine stick and compressed charcoal.

Use hatched line to build up an area of graded tone, working in one direction and varying the pressure.

Loose crosshatching is an alternative method of applying texture and building up tonal areas.

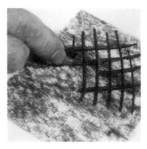

Lay areas of tone with the side of the charcoal stick and crosshatch over the top for a richer texture.

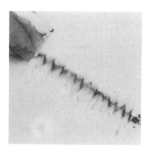

Use a finger to spread charcoal dust evenly over the paper or to vary the tone.

Work lights from tone by using a kneadable putty eraser. A clean piece will erase charcoal completely.

Create areas of pattern and texture by rubbing lines lightly with a kneadable putty eraser without erasing them completely.

Use a charcoal wash technique to soften and spread the tonal areas. Work gently with a soft brush and clean water.

Highlights can be added by using a white chalk or pastel. This is particularly effective on tinted paper.

ARTIST'S TIP

If you are going to use erasing methods extensively, it is wise to experiment a little beforehand with the paper. Generally a hard paper with a slight tooth (see page 73) is best, as this will give depth to the charcoal and also allow the drawing to be erased without too much damage to the surface of the paper.

How can I achieve different textures with charcoal?

Blending techniques allow you to create a range of different textures with charcoal. For instance, for a highly reflective material such as satin you can create subtle gradations of tone by rubbing the charcoal with a torchon or rag, working back into the drawing to define edges of folds, and using an eraser to make highlights. A kneadable putty eraser allows you to create positive, precisely shaped white areas, and can also be used with minimum pressure to modify tones.

For the duller surfaces of materials such as wool, a slight rubbing is usually sufficient for the highlights, which are relatively unobtrusive, and a compressed charcoal can be brought in for the more intense shadow areas.

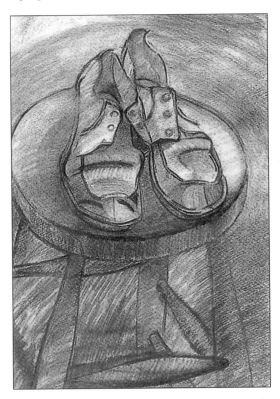

Left: *Worn pair of shoes*, Viv Foster, charcoal *The relatively dull texture of this worn pair of shoes has been rendered with line and broad areas of tone. The artist has used a kneaded putty eraser to lightly rub out the highlights as required. The resulting image provides a sense of character, not only of the shoes but also of the wearer.*

What is the process for subtractive drawing with charcoal?

Normally, darks are gradually built up in drawings, but with charcoal it is also possible to work the other way around, beginning with the dark tones and "subtracting" the light ones, using a kneadable putty eraser.

The method is simple. You begin by covering the whole of the paper with charcoal – compressed or scene-painter's charcoal are best for this (see page 27). Rub the charcoal well into the paper so that it becomes dark gray, then draw the subject on this gray ground. Do not put in too much detail, and do not erase if you make a mistake; just rub the lines into the background and redraw them. When you have finished the drawing, lightly rub over the lines so that they are still visible but merge into the background gray. (If you are confident about your subject, you can omit this drawing stage.)

The strongest highlights should be picked out first, so look at the subject carefully and decide where they are, and then use the eraser to "lift" them out. When the main highlights are in place, begin to work on the mid-tones, and strengthen the darker areas if necessary to complete the work.

Technique study: Subtractive drawing

1 Spread charcoal evenly all over the paper, then lift out the larger areas of lighter tone with a kneadable putty eraser as shown.

2 Now use the corner of the kneadable putty eraser to remove more of the charcoal, thus beginning to "draw" the front edge of the door.

3 After using the kneadable putty eraser, the marble-topped table in the foreground has begun to take shape. Now apply more charcoal to darken and define the rim.

4 It is not always possible to remove all the charcoal, so use a little white pastel to make the areas of highlights pure white.

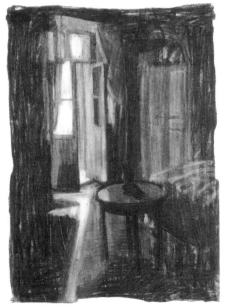

5 Continue to lift out all the light areas and apply more charcoal to darken other areas. If necessary, fix the drawing when finished.

ARTIST'S TIP

This is an exercise often given to art students, as it has a liberating effect, particularly on those who become overly dependent on using line. You can draw any subject in this way, but it should be something that has strong tonal contrasts. An interior lit from a window, with some areas in shadow, or a portrait strongly illuminated from one side, would be suitable subjects.

What are carrés?

Carrés, or hard pastels, are generally classed with the charcoal media grouping. Traditionally, these are available in black, white, and two earth shades: bistre, a dark brown, and sanguine, a terra-cotta. They are lightly baked into a square-sided stick form, and have a density and crispness of mark similar to charcoal pencils. This addition of a limited color choice makes them an ideal tool with which to progress from monotone and a simple introduction to drawing in color.

Above: *Carrés are available in a range of black tones and should be fixed to avoid smudging.*

How are carrés applied?

Carrés are used in much the same way as charcoal (see page 28); the key application techniques are shown below.

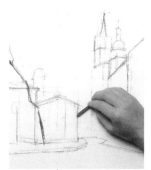
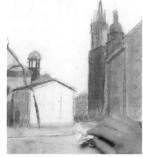
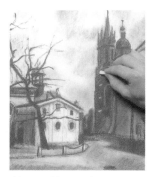

Draw lines with a carré stick of varying thickness.

Soften and blend carré as you draw with paper, cloth, or a dry brush. To be more precise, use a paper torchon.

Use a white carré to create highlights as you work.

What are the characteristics of conté crayons?

Conté crayons are red ochre pigment and are available in four colors – two browns, black, and white – and in both stick and pencil form. Their reddish color, often called red chalk, or sanguine, has a particularly pleasing quality, and has been widely used for figure drawings, portrait, and landscape studies throughout the history of art.

Like charcoal and pastels, the tip or edge of a conté crayon can produce a fine line, or it can be used on its side to create broad areas of tone. You can also exploit different textures of paper – heavy pressure on smooth paper such as cartridge will achieve solid blacks, whereas a rougher surface such as watercolor or pastel paper will break up the tone to create a speckled effect.

Some artists prefer conté crayons and pencils to either charcoal or graphite pencils because they produce such strong, positive effects. Their main disadvantage is that they are more or less impossible to erase, but they smudge less easily than charcoal, and do not need to be fixed.

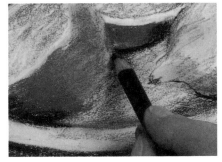

Above: *Use conté crayons on their tip or their side to create the desired marks.*

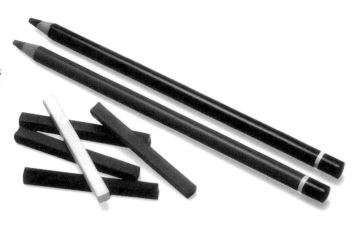

Right: *Conté crayon is made in both stick and pencil form. Sticks can be sharpened with a knife if desired.*

Paper texture

Left: *In charcoal, pastel, and conté crayon drawings, the texture of the paper is an important factor. This shows conté crayon applied to drawing paper, which is relatively smooth and does not break up the strokes to any great extent.*

Left: *Ingres paper (called charcoal paper in the United States) is made with a laid pattern of even lines, which will show through unless the conté is very heavily applied. This can be used to advantage in a drawing, but it makes it difficult to achieve dense blacks.*

Left: *Watercolor paper has a very pronounced texture, and because the conté will adhere only to the raised grain, it creates a distinct speckling. This can be effective for a drawing in mainly light and mid-tones, but not for one where you want solid blacks.*

ARTIST'S TIP

A warm cream or buff paper is often chosen to enhance the quality of the red ochre pigment.

Right: Leonard Leone, conté *This artist likes a smooth surface for his conté work, and in this drawing of a Navajo Indian he has used a primed wood panel. This would not be suitable for charcoal because it would not provide enough texture to hold it, but conté has a higher degree of adherence.*

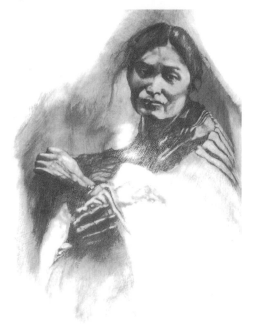

What is the *a trois couleurs* method of applying conté crayons?

This is a traditional method of drawing that uses black and white conté on gray or light brown paper, which allows tones to be translated very rapidly.

The paper represents the mid-tones; the darks are built up with black, and white is used for the highlights.

Technique study: The *a trois couleurs* method

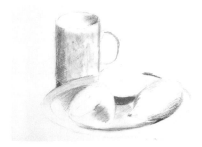

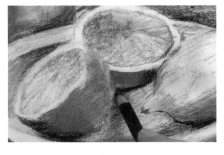

1 To apply conté crayons *a trois couleurs*, choose tonal equivalents – with this limited palette it is rare for the colors to match your subject. Here use light brown conté to define the lemons and the mug.

2 Bring in the darker brown and then the black for the shadow areas. Use a conté pencil rather than a crayon here, as it allows for finer drawing and more definition.

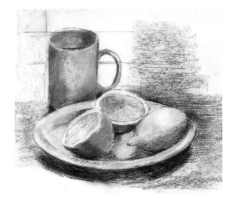

3 Unless you choose a subject with a predominance of browns, it is not possible to achieve naturalistic color, but you can produce an interesting drawing. The method will also teach you a lot about tonal relationships.

ARTIST'S TIP

All five conté colors can be combined in one drawing to build up an effect that almost has the quality of a painting.

What are the advantages of working with pen and ink?

Despite the popularity of newly invented pens intended for use primarily by graphic designers, the ink-dipped nib in a traditional penholder is still the most popular instrument for drawing with ink. This is probably because of the wide range of marks possible with this medium. The fact that the reservoir in the nib holds so little ink, making frequent dipping into the ink pot necessary, seems difficult to handle at first but can prove a real advantage, as it forces you to constantly review your work. This discipline can really help when working on studies or detailed work.

The effects that can be achieved with an ink-loaded nib are numerous. Crosshatching, stippling, splattering, and the sharp, freely drawn line can all be used. Drawings can be given a graded tonality or high contrast, depending on the requirements of the artist. Pen and ink is an extremely versatile medium, and the effects illustrated below and on the next page are shown as a starting point from which to experiment. As always, it is important to try different pens and techniques in order to find those that best suit your style of drawing.

Lines of varying widths are drawn freehand with different nibs. Crosshatching over this creates a tartan effect.

Simple scribbles can be profuse and dense or spare and delicate.

This dotted, or pointillist, pattern has been created by using a fine nib.

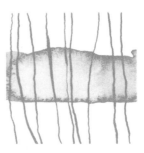

A blob of ink can be blown across the support to create random splotches and streaks.

Use an old toothbrush to splatter ink over a surface, blotting it off if a softer effect is required.

A combination of line and wash requires both brush and pen. Leave the wash to dry before adding the pen lines, here with a dip pen.

What materials do I need to work with pen and ink?

Ink is the oldest of all the drawing media. In Ancient Egypt, reed pens were used with some form of ink for both writing and drawing, and in China, inks were being made as early as 2,500 BC, usually from black or red ochre pigment made into solid stick or block form with a solution of glue. They were then mixed with water for use. These inks, later imported into the West in their solid form, became known as Chinese inks or Indian inks (see page 40).

From late Roman times until the nineteenth century the standard pen was the quill, made from the feathers of a goose, a turkey, or sometimes a crow or gull. The reed pen, however,

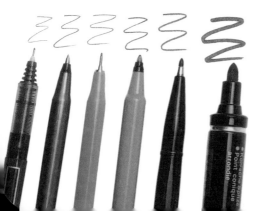

Left: The range of felt- and fiber-tipped pens is bewilderingly large. Try them out before buying, and make sure they are colorfast – some fade badly.

Bamboo pens *are used by both artists and calligraphers, and are usually available from calligraphic suppliers. They are versatile and exciting to use, but you will need some practice.*

Quill pens *are also used by calligraphers, and were in the past the standard tool for both writing and drawing. They are very sensitive, and provide a range of different kinds of line.*

Reed pens *are similar to the bamboo but slightly thinner; they are well worth trying out.*

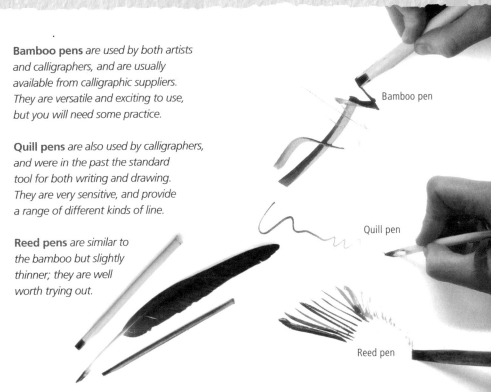

Bamboo pen

Quill pen

Reed pen

continued to be used and still is. Quill pens can be made quite easily, and some artists still do this, finding quills more sympathetic than metal-nibbed pens. A rather similar kind of pen, made from bamboo, has been used for centuries in the East. This is thicker than the reed or quill pen, and gives a very attractive, rather dry line. Bamboo pens can be bought in some specialty art stores, or again, you can make your own.

If pen and ink is a medium you find you enjoy, it is worth experimenting with homemade pens. However, there are a great many different drawing pens on the market today, from the old-fashioned (but still much used) dip pen, with a wooden handle and interchangeable nibs, to reservoir pens and various ballpoints and fiber-tips. You may need to have several different types of pen to suit the particular job in hand. For example, ballpoints and felt-tips do not offer much variety in the kind of lines they make, but they are convenient for outdoor sketching. Dip pens and bamboo pens are more versatile as drawing implements, but less practical for location work, as they require you to carry a bottle of ink.

Simple starting kit

There are many kinds of drawing pens and drawing inks, but to begin with, use a small bottle of black drawing ink and a dip pen that can take separate nibs. Drawing ink can usually be diluted with distilled water, so make sure that any ink you buy can be thinned in this way.

Below: *There are many different drawing inks, but the two main categories are waterproof and water soluble. There are also many different drawing pens, but a dip pen with interchangeable nibs would be a good first buy*

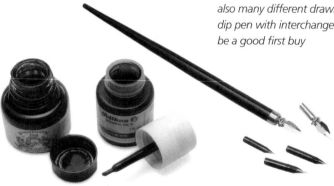

What is the difference between Indian and Chinese ink?

Indian ink (commonly known as drawing ink) is especially made for use in permanent works of art, such as pen drawings, wash drawings, and mechanical drawings; it comes in liquid form. Chinese ink is similar to Indian ink, although various minor ingredients are added to enhance its brilliancy, working qualities, and range of tone. After this ink is made, it is dried and molded into little sticks or cakes, which the artist puts into a solution by rubbing the ends on an inkstone with a little water. Chinese block ink is still widely used for brush drawing.

What surfaces work well with pen and ink?

When working with this medium, it is best not to work on too small a surface. A slick or smooth acid-free paper surface will work well with pen and ink because it holds the marks and does not allow them to bleed or break. However, when working on a softer paper such as cartridge, mistakes can be remedied by painting out and overdrawing. Various opaque white correctives are available, quick drying and very hard, and all are useful to have on hand.

If work is being done on a card or illustration board, then a common technique employed to make adjustments and even major corrections is to scrape the top surface off, using a sharp craft knife or a single-edged razor blade. It is essential that the cutting edge, in this case the scraping surface, be kept almost flat against the support so that mistakes can be erased without tears or scratches. If they do appear, the area affected should be burnished flat.

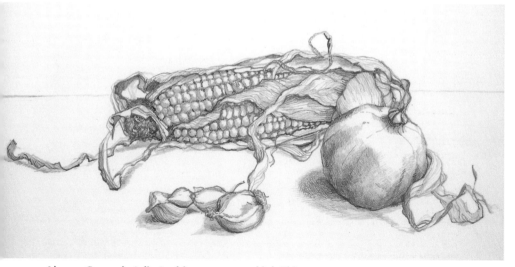

Above: *Corncob*, Julie Joubinaux, pen and ink *This drawing was worked with brown ink on an acid-free hot-pressed (smooth) watercolor paper.*

Are inks available in colors other than black and blue?

Yes, and drawing in colored inks, both with a limited and a comprehensive range of colors, can really extend the possibilities of pen-and-ink drawing. They can be used with pens, brushes, or any sticklike instrument, and they add another dimension, not only as colored lines and washes of color but also when used to describe objects in their identifiable local colors.

Some colored inks (sometimes described as liquid watercolors) are water soluble, and can be diluted and intermixed or applied as washes if required. Other shellac-based inks (often called drawing inks) can be diluted with distilled water and have brilliant, transparent colors. With waterproof inks, the pens and brushes have to be carefully cleaned after use, or the ink will dry on them and be impossible to remove. Waterproof inks should never be used in any kind of pen that has a reservoir, such as a fountain pen or technical drawing pen.

Above: *A wide selection of inks in many colors is available. Artists' drawing inks are waterproof, drying to a glossy film that can be overlaid. They come in many colors, although black Indian ink is most commonly used for drawing. Nonwaterproof inks dry matte and have the same effect as diluted watercolors. They can be further diluted and blended when water is washed over them with a brush.*

ARTIST'S TIP

Two reds (one a crimson), a blue, a yellow, a green, and black would be sufficient to start working in color with pen and ink.

Are inks lightfast?

Traditional, lightfast drawing inks are available in black and a limited range of colors. However, many modern inks, with a much larger range of colors, are dye-based and not permanent, making them unsatisfactory for substantial work; acrylic inks fade less. Unlike water-soluble inks, waterproof ink has a varnish content that fixes it when dry, and subsequent applications cannot disturb it. Inks stain paper permanently, so dilute them to a pale tint using distilled water or use dot-and-stipple techniques if you want to make a cautious start.

> **ARTIST'S TIP**
> Use only distilled water to dilute waterproof ink, or it will curdle.

How do I build up tone with pen and ink?

The traditional method of building up a tonal drawing with a pen is by hatching and crosshatching. Hatching and crosshatching lines should be roughly parallel, but they do not have to be straight and completely even. Although a very controlled, regular network of lines could be suitable for a subject such as a building, in general you should aim to create as much variety as possible in a drawing, or it may become dull and mechanical. If you are drawing a solid form like the trunk of a tree, or a figure, try letting the hatching lines follow the contours of the form. This is called bracelet shading, and was pioneered by the great German artist Albrecht Durer (1471–1528).

An equally effective but harder-to-handle method for defining tone is scribble line, which was used by Pablo Picasso (1881–1973). The pen is moved freely and randomly backward and forward until the right density of tone is built up. This method requires practice, but is well worth trying, as it creates a wonderfully free and energetic effect. The energy can, however, be at the expense of control, as you cannot achieve very precise effects.

Technique study: Hatching and crosshatching

1 Using a fine fiber-tipped drawing pen, lay in a set of hatching lines.

2 Now begin to build up the darker tones. Erasures are not possible with pen and ink, so it is wise to begin with a light pencil drawing.

3 Use the hatching and crosshatching method to produce areas of dark tone. Here the lines are diagonal, in contrast to those above, which describe the flat plane of the windshield.

4 Continue varying the hatched and crosshatched lines, both to give the drawing more interest and to suggest the different shapes and planes.

Technique study: Scribble lines

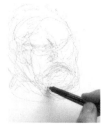

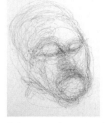

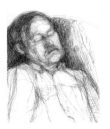

1 Begin by drawing a series of loose lines roughly following the main forms of the head and face.

2 Increase the network of lines so a definite impression of the head begins to emerge, though as yet make no attempt to define the features in detail.

3 In the final stages, build up the forms of the head and body with further scribbling. The effect is softer and less precise than that produced by hatching and crosshatching.

What is the line-and-wash method using ink?

Line-and-wash drawing with ink is a traditional technique with a long history, and is still deservedly popular for its expressive and suggestive qualities. Because you do not have to rely on the pen line to provide tone, it can be a freer and more rapid drawing method than hatching with pen and ink. Forms and impressions of light and shadow can be suggested with a few brushstrokes, strengthened with touches of line where necessary.

It is important to develop both tone and line together rather than drawing an outline and then filling it in with washes. If you are new to this technique, you might begin with a light pencil drawing that will act as a guide for the first areas of tone. You can then add line and further tone as the drawing demands, or you can work with a pen with water-soluble ink, which you can spread by washing areas of the drawing with clean water.

Technique study: Line and wash

 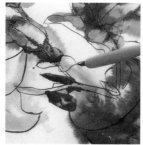 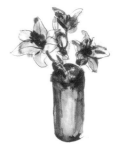

1 To create the effect of the soft petal, work on dampened paper, which will cause the ink to spread and diffuse. Use a Chinese brush to drop undiluted ink lightly into a paler, dilute wash to create the darker areas of tone.

2 Allow the first washes to dry before using a dip pen to add clear definition to the stems and the petals.

3 Add further areas of wash after the pen lines to pull the drawing together. Take care to prevent the drawn lines from dominating; here the piece is well integrated.

Can I use a brush alone to draw with inks?

Brush and wash is a technique where lines are made with just the point of the brush. Rembrandt (1606–1669) produced some wonderfully expressive figure drawings in which both figures and their surroundings were suggested with a few strokes of brush and ink, used at different strengths. Brush and wash is an excellent method for making quick tonal landscape studies that could be developed into a painting or finished drawing.

The linear qualities of the brush can be used with a variety of colored inks. The marks you make are dictated by the type and size of brush you use, the direction and pressure of the stroke, and the way the brush is held. You can use any good-quality brushes, but sable is preferred, as these are firm and springy, and hold the ink well. Or you might like to try Chinese brushes, which are now readily available and relatively inexpensive.

Technique study: Brush and wash

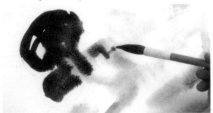

1 First dampen the paper and start to apply diluted ink with a brush. Drawing directly with a brush is very satisfying, as well as being an excellent method for quick studies.

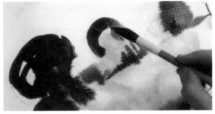

2 Now lay undiluted ink over a still-wet paler wash.

3 The Chinese brush is a sensitive drawing tool; use it here to make both bold lines and small pointed shapes suggestive of trees.

4 Although unfinished, the drawing gives a good impression of the fields and trees, and the effect of the spreading ink in the foreground is attractive in itself.

What is the effect of water washes on shellac-based ink?

Inks made with a shellac solution can be applied with a brush, pen, or airbrush and are widely used by artists, illustrators, designers, and calligraphers. These inks come in brilliant colors and are fast drying and water resistant. You can mix them and dilute them with distilled water, and they have an excellent adhesion on most surfaces.

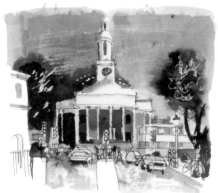

Above right: Eric Brown, line and wash *This drawing is mainly completed in tone, applied with dilute washes of shellac-based ink. The effect of water on this type of ink sometimes has odd results – in the sky area you can see how it has turned yellowish in places and has an opaque blue-white "bloom" in others. Always be on the lookout for accidental effects like these that you can use to advantage. The white scribbled lines on the trees and in the sky were produced by the wax-resist technique (see page 76).*

What is blot drawing with ink?

It is now accepted that accidental effects can be an important feature of drawing, but this is not a new discovery. Alexander Cozens (1717–1786), an English painter and eminent drawing master, took an idea from the fifteenth-century artist Leonardo da Vinci (1452–1519) and developed it into a method for producing landscape drawings. The idea was the simple one of dropping blots of ink onto paper and then developing a landscape from these random marks.

Above: *Blots of Chinese ink dropped from a stick have been developed into a landscape by adding lines drawn with the same stick.*

To try this technique, take a new sheet of paper and drop ink first from a stick, then from a pen and a brush. Look carefully at groups of blots, and see if their accidental arrangement suggests something to you. You may see the marks as dark clouds, plants, a face, or perhaps figures. Let your imagination wander freely, and once the blots have suggested something to you, try to develop this image using more blots or ink lines made with a pen or a brush so that the imagined subject becomes clearer. Then try the experiment again, but this time first wet the area of the paper on which you are going to drop blots with clean water.

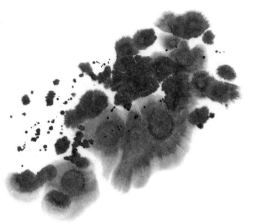

Above: *Blots dropped onto wet paper form interesting patterns that may suggest a subject.*

What are the characteristics of marker pens?

Marker pens, under which heading I include felt-tip pens, are available in a wide variety of colors. They have pointed or wedge-shaped nibs, and the colors they contain are either water-based or spirit-based. The spirit-based colors tend to spread, "bleeding" beyond the shape drawn by the nib. They also have a tendency to bleed right through the paper, particularly in sketchbooks, where they can ruin a drawing on the previous page. There are some specially manufactured marker pads made with paper that largely controls the problems of color bleeding.

Right: *Markers are made with both fine tips (right) and broad, wedge-shaped ones (below).*

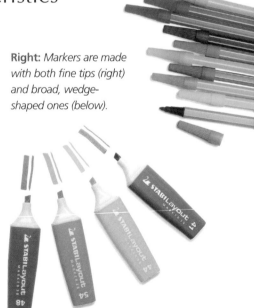

Can you mix marker pens?

The ink of marker pens is transparent, so you can mix colors by laying one color over another. This requires practice, but vigorous, brilliantly colored drawings can be made with markers and felt-tips, and it is well worth trying them. Markers come with either a pointed or a wedge-shaped nib, broad or fine, and may contain water-soluble or spirit-based ink. Newcomers to the medium should start with water-soluble markers, as the spirit-based inks tend to spread, bleeding into the paper surface beyond the passage of the nib. You do not need a lot of colors to try this medium; start with a crimson and a brilliant red, a blue, a yellow, a bright green, and black.

Above and left: *Markers are excellent for quick sketches, giving them a vivid impression of form and color that can later be developed through more detailed drawings. Overlaying the transparent colors creates a sense of depth, and the movement of the pen tip contributes a vigorous quality to the subject even when, as shown, it is rendered only as simple color blocks.*

Are marker pens lightfast?

Marker pens are unpredictable, as they change and fade on prolonged exposure to natural light. All artists' media are slightly variable from one pigment to another, but for practical purposes they are relatively stable, whereas some types of marker or felt-tip pen colors degrade quite quickly. One solution is to use these media in combination with others, and to apply fixative, which will slow the degradation of color values.

They are certainly extremely useful tools for sketching and working drawings, being a source of varied and fluid color that is also easily portable and does not require use of a diluent or solvent. In these contexts permanence is not essential. Keeping examples of your sketches and color roughs over a period of time also provides a way of monitoring the relative stability of the colors.

What are the characteristics of pastels?

Pastels are colored sticks made from powdered pigment (the basis of all paints) held together with the minimum of binding medium. They can produce brilliant color effects and are exciting to use, although practice is needed to use them well. Pastels are made with different degrees of hardness, and some are available cased in paper or with a plasticized coating to protect your fingers from the color, which powders and rubs off easily.

There are also pastel pencils, which are cleaner to use but lack the versatility of "real" pastels. Pastel sticks can be used on their sides to lay in broad areas of color, but with pastel pencils you obviously cannot do this, and they tend to produce a less sharp line than can be made with the corner of the conventional square-section stick.

Right: *Hard pastels can be combined with other media or used on their own.*

Below: *Soft pastels, also known as chalk pastels, are available singly or in boxed sets.*

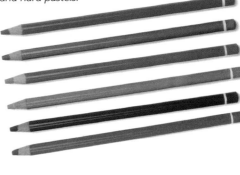

Below: *In terms of softness, pastel pencils fall somewhere between soft and hard pastels.*

What are the advantages of working with pastels?

The primary advantage of this medium is its immediacy of effect, as you only have to rub the pastel stick over the surface for it to release its characteristic strong, pure color. You can use pastels to produce a variety of drawings and paintings, as you can apply them dry to create fine line details or blocks of color. You can use them on many different surfaces and combine them with other media to produce unlimited effects.

Because they are mixed directly on the surface, they retain their luminosity, and they are readily available and convenient to use. And because they are dry, you can stop and start working with them when you choose. Pastels are spontaneous, yet highly predictable; the downside is that they are very vulnerable to damage and mold more than most media. They therefore need to be fixed in the same way as charcoal.

What surfaces work well with pastels?

The texture of the paper will significantly affect the appearance of your pastel strokes. Pastels are almost pure pigment, with just a little of the binder gum tragacanth used to hold the colored powder together (hard pastels have a higher proportion of this binder). If pastels are used on smooth paper, such as drawing, the pigment will tend to fall off, so the papers made for pastel work have a slight "tooth," or texture, that "bites" the particles of pigment and holds them in place (see page 73).

The two best-known papers sold for pastel work are charcoal paper, which has a laid pattern of small, regular lines, and Mi-Teintes, which has a pattern resembling very fine wire mesh. But

there are many other suitable surfaces, including watercolor paper, which breaks up the strokes and gives a slightly speckled look. Artists who paint rather than draw in pastel, building up colors thickly, also use velour paper, which has an attractive velvety quality, and a type of fine sandpaper made especially for the purpose.

Unless very heavily applied, pastel marks do not cover the paper as thoroughly as paints or inks. For this reason pastels are usually done on colored paper; otherwise little flecks of white jump out and spoil the effect of the colors. This is not to say that you can never work on white paper; if your approach is mainly linear, you

may find it quite satisfactory, but for a more "painterly" drawing you will find colored paper helpful. Not only will it blend in with the pastel colors if the color is chosen wisely, but it will save you from having to cover the whole surface. For example, if you draw a still life against a blue background, you could choose a blue paper of suitable hue and leave areas of it uncovered.

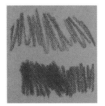
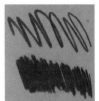

Above left: *Watercolor paper is loved by some pastelists, but others hate it. As you can see, its surface breaks up the pastel colors, giving a speckled effect, and it is virtually impossible to push the color right into the grain.*

Above right: *Charcoal paper is made specially for charcoal work, and is also popular for pastel and conté drawing. It is not suitable for a very heavy buildup of overlaid colors.*

Above left: *Mi-Teintes paper is the other "standard" paper for pastel work. Some find the heavy grain overly obtrusive, and prefer to use the "wrong" side, which is smoother but still has sufficient texture to hold the pigment.*

Above right: *Velour paper is expensive, and available only from specialty suppliers. It gives an attractive soft line, with no paper showing through, and is ideal for those who like to build up thick layers of color.*

What type of strokes are used with pastels?

With a linear medium, such as colored pencil, the variety of different marks you can make is limited. The beauty of pastel sticks, whether you are using the soft or the hard variety, is that you can apply marks with the side of the stick as well as the tip, which allows you to range from broad, sweeping lines to fine, precise ones. And these can be further varied by increasing or decreasing the pressure.

If you have not used pastel much, it is worth experimenting with both linear strokes and side strokes to get the feel of the medium and begin to develop

your own "handwriting." Side strokes are best done with a fairly short length of pastel, so snap a stick in half. You will then be able to draw lines with the resulting sharp edge. You can achieve very fine lines in this way, particularly if you are using hard pastels.

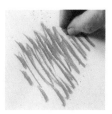

Diagonal hatching can be laid in by using the side of the stick of pastel. The thickness of the lines depends on how firmly you press.

By rubbing the hatched lines with a fingertip, the color can be spread and a hazy effect achieved.

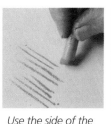

Use the side of the pastel and press lightly to obtain crisp, fine lines.

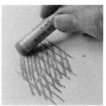

Working across these lines in the opposite direction results in a crosshatched textural effect.

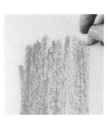

Lay an area of color with the blunt end of the pastel by working along the grain of the paper in one direction only, being certain to use firm, even pressure.

Peel back the protective paper and hold the pastel flat against the support to obtain a broad area of grainy color.

Use a kneadable putty eraser to create highlights and to lift off color and achieve paler tones.

Make brisk strokes across the grain of the paper with the blunt end of the pastel to create a stippled effect.

What is the process to build up colors in a pastel drawing?

If you are using a fairly small range of colors and want to achieve subtle effects or rich, dark hues, you will have to "mix" colors on the paper by overlaying. The hatching and crosshatching methods are suitable for the whole range of pastels. For broad effects made with side strokes you can overlay colors more directly, simply by putting one stroke over another. If you are working on heavily textured paper, you can make a good many such overlays, but lighter paper will become clogged with pigment more quickly, and you may need to spray with fixative between layers.

The color-mixing technique particularly associated with pastel work is blending (see also page 56), in which two or more colors are laid over one another and then rubbed with a cotton ball, your fingers, or a torchon so that they fuse together on the paper. This particular method allows you to achieve almost any color or tone possible, but it is not wise to overdo the blending technique, as it can tend to make your drawing look bland and insipid. Try to combine the technique with vigorous lines, or carefully fix the blended color and draw over it.

Technique study: Building up with line

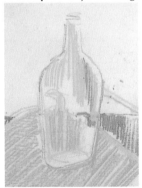

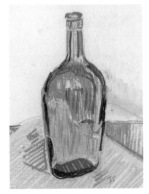

1 Use the pastels to lay a series of firm hatched lines to describe the basic forms and colors of the bottle.

2 Now introduce darker colors, using the same method of application.

3 The line direction has been varied to express the forms of the bottle and the two separate horizontal planes.

Technique study: Blending

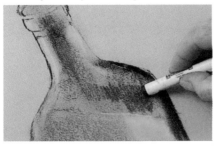

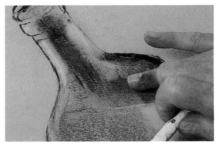

1 For blending you will work in a completely different way, rubbing the colors into the paper to create a soft effect. Here, modify the green with a touch of white.

2 Rub with a finger to blend one color into another. A gray paper (the "wrong" side of Mi-Teintes) has been chosen, as this makes it easier to judge both the darks and lights.

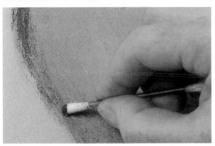

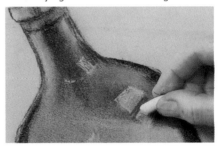

3 A finger would be too clumsy an implement for the blending on the side of the bottle, so use a cotton swab instead. Many artists prefer these to torchons, as they have a gentler action.

4 Because pastels are opaque, light colors can be laid over dark ones provided there is not too much buildup of color on the paper surface. Thus leave the highlights until last.

5 This makes an interesting contrast with the other demonstration; here there are no visible lines. The two methods can, of course, be combined in one drawing.

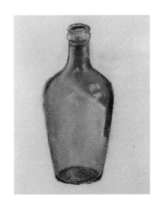

ARTIST'S TIP

When applying pastels, work from dark to light, as dark colors will muddy and obscure lighter ones.

What are some specific techniques for blending pastel colors?

The common feature of all pastels is that they are mixed when they are applied to the paper, not in advance. Because this is a slow process, manufacturers offer a wide range of shades to minimize the need for mixing, but because the available colors will not always match your requirements exactly, it is worth taking the time to learn different ways to blend colors as shown below.

Expand your color list so that you can keep blends simple, adding light browns for darkening yellows, and dark browns and purple for reds, extra-dark greens, and dark blues. Black does not create effective shadows, as it colors mixtures. Unless they are particularly deep and somber, shadow colors are richer versions of the color they fall on, so use dark colors to make them.

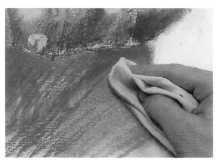

Above: *Blending with a cloth to remove dust from wide areas.*

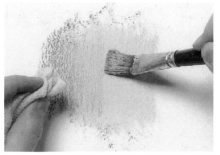

Above: *Blending with a bristle is controlled, as the brush edge provides definition.*

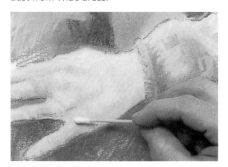

Above: *Blending on small-scale, loosely defined areas with a cotton swab.*

Above: *When kept clean, a torchon allows specific blending with minimal dust removal.*

What are some additional effects you can get with pastels?

The primary advantage of the medium is its immediacy of effect, as you only need to rub the stick over the surface for it to release the characteristic fresh, pure color. With this in mind, try out some of the techniques shown here to develop your repertoire of pastel techniques and enhance your drawings.

Technique study: Laying an area of tone

1 Use the blunted end of the pastel to draw in a fairly small area of thick color.

2 Work the color over the area, using a fingertip and spreading the color lightly from the center.

3 A torchon is more accurate than the fingers for putting the color exactly where you want it to go.

4 Rub the toned area with a piece of newspaper to push the pastel into the support and set the color.

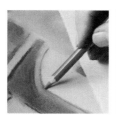

Above: *Pastels in pencil form are easily sharpened and therefore suitable for adding detail.*

Above: *Excess pastel color can be easily lifted by brushing gently with a soft paintbrush.*

ARTIST'S TIP

With soft pastels, you can scrape the edge of the stick with a knife or blade to release the powder, then spread the powder on the paper using your fingers or a rag.

What are oil pastels?

Left: *Oil pastels, like soft pastels, can be bought in boxes or singly.*

Oil pastels are a relatively recent development and have an entirely different range of possibilities from traditional hard and soft pastels. Used in association with, for example, pens or watercolor, they provide a richness that is the result of the oil-bound pigment, but they are also an important medium in their own right. Oil pastels vary from stiff to slippery; the softest mix well, and the stiffest are good for drawing a level of detail. Although not really suitable for use in a small pocket sketchbook, oil pastels are very suitable for quickly worked interpretations of a figure or a landscape. Greater control can be achieved by laying a little masking paper beneath your working hand, thus preventing unwanted smudging and smearing.

In common with traditional pastels, oil pastels work well on a colored support. However, they are perhaps best used on white paper, providing them with a distinct advantage over soft pastels. The white paper allows the rich and transparent oily colors to gleam as though lit from behind, and they can form the basis of a design over which watercolor or colored inks can be used, resulting in a type of work that is both elaborate and refined. It is as part of mixed-media drawings that oil pastels are unique, not only when overlaid by watercolor and inks but in association with pen drawing, traditional pastel, charcoal, and pencil. Experiment with white spirit or turpentine, using these solvents to dilute the marks on the paper and create a wash effect, as this works well as a basis for pencil work.

How do you blend oil pastels?

Just like ordinary pastels, oil pastels are generally mixed on the paper by overlaying. They cannot be blended by rubbing, but the color can be melted with white spirit or turpentine, so that you can mix them on the paper very much as you would mix paints on a palette as shown in the demonstration here. Beware in hot weather, when they can tend to melt even without the aid of white spirit, becoming both messy to use and difficult to handle.

Technique study: Mixing using oil pastels and white spirit

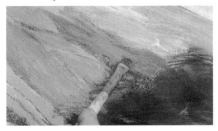

1 Spread the dark color with a rag dipped in white spirit.

2 Now use a brush, similarly dipped in white spirit, to spread the color in the sky areas.

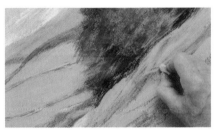

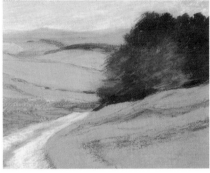

3 Draw over the spread color with the tip of the oil pastel stick, introducing a more linear element into the foreground of the landscape.

4 This method, which combines drawing and painting, is a very quick and effective way of building up areas of color with oil pastel, ideal for location work, when time is often limited.

Right: *For blends in small areas, use a cotton swab or brush moistened with white spirit.*

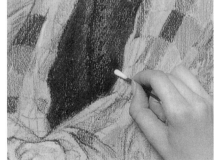

ARTIST'S TIP

Mixing oil pastels with white spirit is quick way to build up areas of color when you find yourself short of time.

What is the process for building up color with oil pastels?

Oil pastels do not dry, so avoid rubbing them, or use special oil pastel fixative. The good news is that they are dustless so you can build up layers of color without the top layer falling off, as can happen with traditional pastels.

Technique study: Building up colors

1 After lightly establishing the main shapes in either pencil or charcoal, start to fill in the group with hatched applications of oil pastels.

2 With this medium the color has to be built up gradually, so continue to identify the main colors in the subject with broad strokes.

3 Pay careful attention to identifying not just the color of an object but also its tone. Apply your oil pastels accordingly by layering a complexity of color strokes over each other.

4 Continue to build up the colors by applying one layer of oil pastel over another.

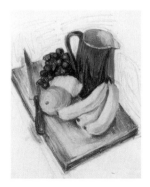

5 Complete the drawing in the same way, by developing the colors further and maintaining the contrasts.

What is sgraffito and how is it achieved?

One of the techniques becoming increasingly associated with oil pastels is sgraffito. In this technique one layer of color is scratched away to reveal another one below to create texture. Sgraffito can either be incorporated early in the laying of colors or used as a finishing technique. It can also be done with soft pastels, provided the first layer of color is sprayed with fixative, but it is more difficult, and the effects are less dramatic.

You will need to work on a reasonably tough paper for this technique – watercolor paper would be a better choice than the standard pastel papers. Start by laying down a layer of solid color; oil pastel covers the paper thoroughly if heavily applied. Then put another color on top and use a sharp implement such as a craft knife, scissors, or pins to scrape parts of it away.

You can make many different effects: Try using the point of the blade for fine lines and scraping lightly with the side to create areas of broken color by only partially removing the top color. You can build up several layers of sgraffito, or vary the color combinations from one part of a drawing to another. The type of instrument used to create the marks, and the way and angle in which the instrument is held, will determine both the style of mark and the ease with which it is made.

Technique study: Scratching back

1 Working on watercolor paper, use a penknife to scrape off the top layer of color.

2 Continue to use the penknife very much as a drawing tool, to manipulate the colors into shapes suggestive of trees.

3 The effect of the sgraffito is not overly obtrusive, but adds a touch of movement and excitement to the focal point of the picture – the group of people relaxing in the sun.

What are water-soluble colored pencils?

Also known as aquarelle or watercolor pencils, water-soluble colored pencils look like traditional colored pencils, but their cores are water soluble. They can be used wet or dry: If you draw on the paper with a dry pencil, you can then wet the area of color with a soft brush dipped in clean water and spread it just like watercolor. You can also dip the tips of these pencils in water and use them directly on the paper if you wish.

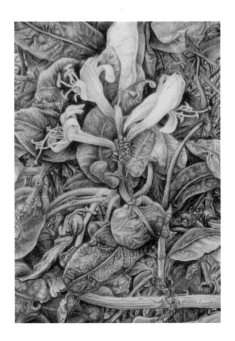

Right: *Some sort of bloom of hope in the thicket of despair*, Paul T. Bartlett, water-soluble pencil *This amazingly detailed and intricate work is in water-soluble pencil, which allows colors to be built up by overlaid washes as well as by line.*

What brushes should I use with water-soluble pencils?

Brushes that point well can be used to make any mark, from a fine line to a sweep of wash. For fine drawing, use a large, springy soft-hair brush that will stay flexible when wet; using a delicate touch, it is possible to make small marks with big brushes, but making marks with a small brush is a laborious task.

Mid-priced synthetic-hair brushes are reliable and predictable; they lack character, but they are useful and long-lasting. Natural hair is highly priced, with sable brushes being the most expensive; they should be considered only if you do a lot of wash drawing, as the outlay is not justified for occasional use. Cheaper alternatives are available, such as Oriental brushes, which use brown weasel hair with a good spring. These are supplied stiffened with protective

starch, but if in doubt ask at your art store about their qualities. Brushes with no spring, or that do not come to a point, will not draw a controlled line.

Wash brushes do not have any spring and are used for flooding large areas with color quickly. A large, traditional, squirrel-hair mop brush may seem costly, but the Oriental alternative of white hair, usually goat, is inexpensive and serviceable.

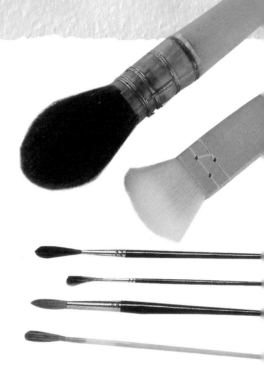

Right: *A good detail brush points well when wet, liners are blunt, and mops are soft-edged.*

Can you suggest a simple palette for starting off with water-soluble pencils?

If you have little experience with color mixing, working with an extensive range of colors can seem confusing. Add colors to your palette in phases, starting simply with the three primary colors – red,

blue, and yellow – with the addition of black and white. From these you can mix secondary colors; add more shades once you have become accustomed to using the primaries.

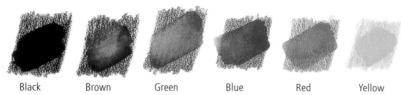

| Black | Brown | Green | Blue | Red | Yellow |

Above: *The swatches of color above illustrate a basic palette of dry and water-diluted colors. Notice how the colors alter when water is applied, and how pale colors do not change as perceptibly as darker ones do.*

How do I apply water-soluble colored pencils?

Water-soluble pencils look like traditional colored pencils, but their cores are water soluble. Hard and soft types are available, hard pencils being precise on wet paper and useful for adding fine details, and soft ones good for making strong washes and reinforcing shades. They can be used as dry pencils, but the pigment dissolves when it is washed with clean water, making it possible to blend colors. If working this way, remember to stretch the paper first (see page 72) and be careful not to flood and wash out the work. To make alterations, erase or wash out the unwanted parts.

In many drawings you may wish to make a combination of water-dissolved color and dry pigment. This can be very effective when the dry color is added over a dissolved base, but remember to let the paper dry sufficiently or it will not only moisten the pencil point and produce an inky line, but will most probably tear the paper. Also bear in mind that when you are handling liquids, they tend to spread fast. Complete blending can, of course, be achieved with water-soluble pencils, but many effects, some of a complex nature, can be created through the combination of dry and water-soluble pigments.

You can draw over dry washes and re-wash if necessary, but because wet water-soluble pencils stain the paper instantly, like watercolor, make sure the wash has dried completely before reworking. The mark is permanent, so if you change your mind at this stage, the only recourse is to apply white gouache to obliterate or lighten the unsatisfactory portion. You can use the water-soluble pencils again when the gouache is dry, but if you re-wash, the gouache will also dissolve, and the color produced will be pale and opaque.

ARTIST'S TIP

Although blending color is one of the main attractions of this medium, it can also prove to be a problem where highlights are concerned. To preserve them, either mark the highlight areas very clearly and avoid them, mask them with masking fluid, or burnish in a white area heavily with pencil.

Above: *If you find it difficult to gauge how much pigment to use to achieve the required strength of wash, try samples on scrap paper.*

Above: *Create color mixtures and blends by washing over dry colors, or apply extra colors to dry washes and wash again.*

What is the process of mixing and using water-soluble pencils?

The perfect start for a beginner to mixing and building up water-soluble pencils is drawing a still life of colorful, natural objects, such as fruits and vegetables, that can be set up at home easily. Work from the same side as the light source, so that the objects are fully illuminated and display maximum color as shown below.

Technique study: Drawing a still life

1 Block in the larger areas of color lightly at first with dry pencils. Begin to build up color strength, again using the pencils dry to block in the solid shades that establish the form of the objects and their surrounding spaces.

2 Brush on washes of clean water, to blend colors and set their tones. Water takes color pigment with it as it sinks into the paper, so check the results at once, before it dries. Unsatisfactory washes can be blotted off.

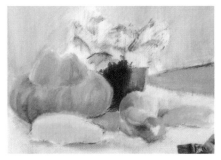

3 Allow the washes to dry, then adapt the color values using dry pencils. Again using clean water, brush the blends of colors to create the more subtle mixtures.

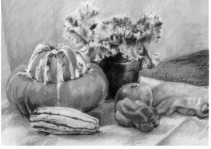

4 Finally, check the tonal values of the colors and if necessary, use tube white gouache to reestablish lost pale tones, such as the banding on the pumpkin.

CHAPTER

2

OTHER EQUIPMENT

Do I need a drawing board to work on?

You will need a flat board to support your paper for drawing, and this needs to be a little larger than the largest paper you are likely to use. Specially made boards can be bought at art stores, but a piece of blockboard, fiberboard or plywood of ½in (1.25cm) thickness is perfectly satisfactory. Chipboard is too rough, and normal hardboard usually is too thin to stay flat.

For fixing the paper to your board use either bulldog clips, drawing-board clips, or masking tape. Drawing pins are not suitable for blockboard or plywood, and some kinds of adhesive tape stick so firmly, they tear the corners off the paper when you remove the board.

Above: *A piece of fiberboard like this is quite adequate for a drawing board. You will also need clips, masking tape, or drawing pins for securing your paper.*

It isn't necessary to have an easel, but you usually need something to support your board when you are drawing. You can use the back of a chair for this when drawing indoors.

How do I sit at a drawing board?

Your drawing position is important, as it is essential to be able to see both your paper and what you are drawing without having to move your head. Try to have the board as nearly upright as possible; if it slopes too much, you will have a distorted view of your drawing. And arrange yourself so that you can see your subject over the top of the board rather than having to peer around the sides.

Right: *Working in the correct position is vital. Arrange yourself and your drawing board as shown for best results.*

What other basic equipment do I need?

Buying lots of equipment is very tempting, but avoid unnecessary expense by buying moderately at first. Besides media, some other basic equipment is shown here:

1 An eraser

A plastic general-purpose one is useful. Gum erasers are built from excessive quantities of gum. They are very maleable and offer a good soft eraser for large areas or for creating smudged or blended effects. A kneadable putty eraser can be bought from art stores, is extremely soft, and can be pressed in the hand into almost any shape.

2 A sharp knife

Either one with replaceable blades such as a craft knife or one with snap-off blades will be useful. A knife can be used both for cutting paper and for sharpening pencils (see page 70).

3 Water pots

Use with rags or paper towels for wiping brushes and general mopping up.

4 A metal straightedged ruler

This will be necessary if you are going to cut paper.

5 A palette

This could be a special artist's chinaware (or plastic) tinting saucer, but an ordinary saucer will do quite well. The saucer is for thinning ink to make washes for drawing.

How, and with what, should I sharpen my pencils?

The way in which you sharpen your pencils and the implement that you use will determine the type and scope of pencil marks that you will be able to create. Fixed-blade sharpeners all create conical, smooth-pointed leads, but offer no flexibility in the shape of the lead and, ultimately, the line it creates.

Soft leads need careful handling – with these, knife blades will offer you greater control. Try using a scalpel, a designer's knife, or a craft knife with a fairly short blade to shave your lead to the required point. It is really a question of finding a knife that you can handle with ease to achieve fine results.

What kind of paper should I use?

Paper is often the critical factor in a drawing no matter what the chosen medium. Although it is not the only support available, paper is far and away the most common, for the reasons of cheapness and portability. Variations in color, texture, weight, and surface make it appealing for most uses.

The range of papers is vast and can be bewildering. In fact, choice is often narrowed considerably simply by the question of availability. If you are unsure about what paper will best suit your purpose, buy only a few sheets at a time. Weight is one factor to be taken into consideration, as it is necessary to stretch lighter grades before starting

work (see page 72). Toned papers provide a good middle ground from which to work darks and lights.

Paper comes in three textures: hot-pressed (HP), the smoothest; cold-pressed (CP) or "not" that has a medium texture; and rough. Hot-pressed is possibly the most generally useful for drawing, but any type can be used with many different drawing implements.

Below: *Cartridge paper is a good all-rounder. Smooth watercolor paper is excellent for ink or ink and wash. Medium and rough watercolor paper, and Ingres paper both give an interesting texture to charcoal and conté drawings.*

Ingres paper

Smooth watercolor paper

Cartridge paper

Medium watercolor paper

What are the sizes and weights of drawing paper?

Paper is usually sold in A sizes, which are internationally recognized. A1 is the largest size and A5 is the smallest you will need. Each size, from A1 down, is half the previous one. You may find the following conversion from A sizes into metric and imperial measurements useful.

A1: 33 x 23³⁄₈in (840 x 594mm)
A2: 23³⁄₈ x 16½in (594 x 420mm)
A3: 16½ x 11¾in (420 x 297mm)
A4: 11¾ x 8¼in (297 x 210mm)

Weight indicates the thickness of paper and is expressed in either grams per square meter (g/m^2 or gsm) or as pounds per ream (500 sheets) – the former is most usual for drawing papers. The heavier the weight, the thicker the paper. Paper of $150g/m^2$ is a good weight for most drawing requirements.

> **ARTIST'S TIP**
>
> Buy drawing papers as separate sheets, as it is less expensive to buy A1 sheets and cut them down when you want smaller sizes.

What is the advantage of colored paper?

Colored papers work well with any drawing media. Their most important advantage is that they can unify your drawing and serve as one of your drawing's tonal values. For example, a neutral-colored paper will establish your medium value; you can then build up your dark and light values around it. This will save you time by removing the need to obliterate the white of the paper or to create a more intricately colored background. Colored papers will also reduce the starkness of black against white and help modulate your palette; using them you can be as bold or as subtle as you want.

Below: Alan Oliver, pastel *In work with soft pastel, the color of the paper is as important as the texture, and here you can see how well the light brown of the paper blends in with the overall warm color scheme of the picture.*

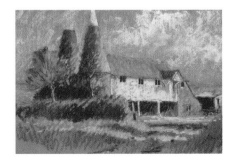

When do you need to stretch paper?

Stretching paper should be done when using any wet drawing medium, such as ink or watercolor washes.

Use a toothed (grained) paper (see page 73) for wash drawings where the amount of pen work is minimal.

How do you stretch paper?

Stretch all but the heaviest papers on a thick wooden board with a matte surface, to prevent the paper from buckling as soon as it "relaxes" when dampened. To check which is the right side of the paper, hold it up to the light; the watermark should read correctly. Use gummed paper tape to hold your piece of paper in place, because self-adhesive tape does not bond to wet surfaces.

A thinner sheet of supporting board may be selected, say for reasons of easy transport, and in this case two strips of gummed paper tape should be laid across the back from corner to corner, crossing in the middle, as an extra precaution against warping as the paper dries. Constant care is needed to guarantee successful results in all your paper preparations.

Stretching paper

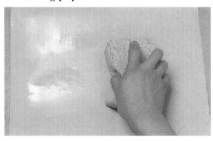

1 Dampen lightweight paper using a sponge and clean water. Immerse heavier-weight paper briefly in the water.

2 Cut strips of gummed paper tape, allowing for overlaps at the corners, and moisten with a damp sponge.

3 Stick a strip of tape along one edge of the paper, half on the paper, half on the board. Press down firmly.

4 Stick tape along the other three sides and leave secured until the drawing is finished. When dry, cut through the tape.

What is meant by a paper's "tooth"?

"Tooth" is simply the grain or texture of the paper. Papers come in various smooth and rough surfaces (see page 70) that suit different drawing media. For example, a pen will draw best on smooth cartridge paper, whereas pastels and charcoal need a rougher surface; the latter is often described as a paper with some "tooth."

The texture of paper will also affect the appearance of the medium you are using. For example, soft pastels are almost pure pigment, with just a little binder used to hold the colored powder together. If they are used on smooth paper, the pigment will tend to fall off, so the papers made for pastel work have a slight tooth, or texture, which "bites" the particles of pigment and holds them in place.

Charcoal paper is a heavy, rough-textured paper, usually with a colored finish. It works well for its purpose, and the roughened feel under a charcoal stick is very satisfactory. It does not take kindly to the use of a hard eraser, its surface being easily damaged; a kneadable putty eraser is best here.

Rice papers are very fragile but are sometimes suitable for work in brush or pencil, often of an exquisite nature. All varieties are highly absorbent if watercolor or ink washes are to be used, but in common with all so-called limitations this can be turned to advantage. The manufacture of these papers differs from that of others – vegetable fibers are chiefly used, resulting in beautiful, refined surfaces.

Working with paper grain

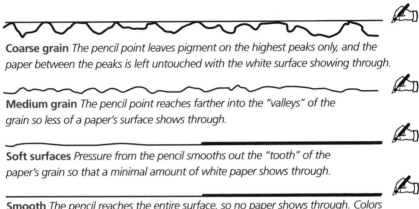

Coarse grain *The pencil point leaves pigment on the highest peaks only, and the paper between the peaks is left untouched with the white surface showing through.*

Medium grain *The pencil point reaches farther into the "valleys" of the grain so less of a paper's surface shows through.*

Soft surfaces *Pressure from the pencil smooths out the "tooth" of the paper's grain so that a minimal amount of white paper shows through.*

Smooth *The pencil reaches the entire surface, so no paper shows through. Colors are lighter because the coating deters the pigment from penetrating the paper.*

What are fixatives and how do I use them?

Fixatives are a mixture of resin and spirit solution, available in aerosols or bottles. They are used with dusty media, such as charcoal and soft pastels; colored-pencil artists also use them on finished work. They can be used with any media that rub off or are smudged when they are touched accidentally. Keep applications of fixative light, particularly on soft pastels, because media are easily dimmed with heavy application of this substance.

Fixatives come in several brands, some specially formulated for a particular medium. They are available in Workable, Matte, Satin Gloss, Gloss, Triple Thick, Kamar Varnish, and a UV inhibitor, all of which have different finishes and properties. Ask at your art store to find out which is right for your medium.

Fixative is applied either from an aerosol can or a mouth-activated spray. The aerosol cans are convenient, but the ecologically conscious would almost certainly prefer to use a spray. The fixative can be obtained ready-mixed in a bottle; there are in addition a number of old and well-tried formulas for mixing fixatives.

Applying fixative

The application of fixative can be carried out with the drawing in either a vertical or a horizontal position. If the work is in a horizontal position, take care not to over-apply the fixative, because it may cause runs, and not to have the spray too close to the work. This latter caution relates particularly to works in pastels that can be blown off the paper when a mouth sprayer is used. Always take precautions to apply fixatives in a well-ventilated room or outdoors and follow the manufacturer's instructions.

Above: *Fixatives can be bought ready to use in spray cans or bottles, and are sprayed through a mouth sprayer.*

ARTIST'S TIP

Beginners should lay the work horizontally and spray the fixative evenly across the surface so that it falls gently and evenly onto the work.

Above: *When using an aerosol fixative, never inhale the spray. Avoid breathing if spraying out of doors, or by leaving the room until the air clears.*

Above: *Bottled fixative is sprayed through a mouth sprayer. It can also be used to spray plain water, to settle dusty media between drawing stages.*

What is wax resist and how do I use it?

One of the mixtures of incompatible materials that has now become very well known, and is used extensively in both drawing and painting, is that of oil and water. If you draw with a wax crayon, and then put down a wash of diluted black ink or colored ink – or draw over it with a marker – the wax will repel the color so that the drawing stands out clearly from the ink wash that has been applied over the top.

Wax resist takes advantage of this incompatibility, and is an enjoyable and exciting technique because it has an element of unpredictability – you cannot be sure how the drawing will look until you have put on the color. You can simply make some broad splotches with white wax crayon, or a household candle, to create areas of texture or color in a background, but you can also build up a whole drawing by a layering method, applying colored wax crayon, then ink or marker, then more wax crayon, and so on. You can even scratch into the wax in places, using the sgraffito technique mentioned in the context of oil pastels (see page 61). Ordinary wax crayons (the kind sold for children) are adequate for simple effects, or you may like to try wax-oil pastels, which come in a wider color range.

Technique study: Wax resist with wax crayon and ink

1 Using wax crayon, start by scribbling lightly over the trees. It takes some trial and error to discover how much pressure to apply, but in general, the denser the application, the more successful the resist.

2 Add a first application of ink and then leave the drawing to dry before adding more wax, and then more ink. You can see how the color has slid off the waxed areas.

3 In this area the wax resist is not intended to be very obvious, so use a color close to that of the ink that will be used on top.

4 This photograph, taken with the ink still wet, shows the effect very clearly, with the ink forming irregular blobs and pools.

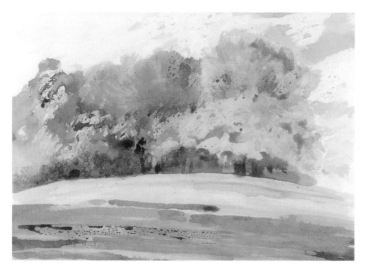

5 The lighter oil pastel colors resist the ink more effectively than the darker ones. Notice how the white used for the clouds has completely blocked the ink.

CHAPTER

3

BASIC PRACTICES

How do you hold a pencil for drawing?

Because we write with pencils, there is a tendency to hold a pencil for drawing as we do for writing. This gives maximum control and is fine for detailed areas of shading and line, but it can lead to rather stiff, unexpressive drawings. Unlike writing, when your hand rests on the paper, a drawing grip should enable you to make wide movements and keep your hand off the paper, to avoid smudging. Often, standing at an easel and drawing from the shoulder rather than the fingers and wrist can transform the way you draw.

Practice making marks on scrap paper until you feel comfortable holding a pencil lightly, grasping it well away from the point. And try different ways of using pencils, perhaps drawing with a sharp point in one part of a drawing and a blunt end in others. For faster, broader marks try using solid graphite sticks (see page 14), with the same composition and grades as pencils. Use the side of the stick for broken or rapid covering, after scraping off any protective lacquer.

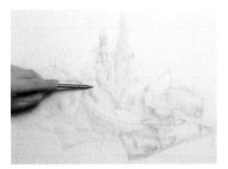

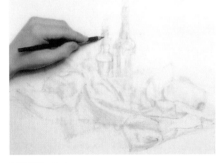

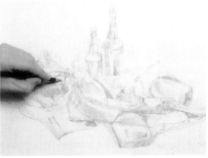

Above: *Try different ways of holding a pencil; all produce different effects.*

ARTIST'S TIP

As a general rule the point should be kept sharp; blunt points make uncontrolled marks.

How can I get started with materials and marks?

Before you start to draw objects, you need to become familiar with drawing materials and the marks you can make with them. To get started with this, take a selection of drawing media, a drawing board, and at least five sheets of white drawing paper, and clips or tape to fix your paper to the board. You can work with your board flat on the table for this project. Attach one of your A2 sheets to your board and begin by drawing on it with all the media you have in turn.

Do not try to draw anything specific, but instead let yourself become totally involved in the lines, dots, and kinds of shading that each medium will produce. Use your imagination and spend at least thirty minutes trying out every way you can think of to make marks with each drawing medium. It is rather like practicing handwriting. Once you are confident about what each medium can do, you will be on the way to using them to describe what you see.

Marks made with a 2B pencil.

Black, white, red, and brown conté crayon. The white has been drawn over black and brown.

Charcoal smudged with a rag and rubbed with a finger.

Fine-point fiber-tipped pen.

Marks made with an HB pencil.

Ballpoint pen (biro).

Dip pen with a fine nib and Chinese ink.

Brush and India ink.

What is an "automatic drawing"?

To assist in releasing the subconscious, the Surrealists developed the practice of "automatic drawing." They believed that if you allow your hand and arm to move freely, without conscious control of the drawing process, you will draw what is in your subconscious mind. A degree of automatic mark-making is evident in the work of many artists who make no claim to being Surrealists. Look at reproductions of drawings by Pablo Picasso (1881–1973) or Henri Matisse (1869–1954), for example, and see which you feel contain lines drawn with an automatic sweep of the artist's hand.

Use a new sheet of paper to try making your own automatic drawings. Start by using any or all of your drawing media and make sweeping lines down or across the paper, moving your hand and arm freely. Next think of the foliage of a tree and then try to describe it with freely drawn lines. Rather than by strict adherence to drawing principles, allow your hand to be guided by impulse, prompted by imaginary kinds of foliage that come to mind. The result might be something like the drawing below.

Then imagine a town seen from a distance and try to draw it. When you are drawing, do not take your drawing instrument off the paper more than is absolutely necessary. As far as possible, draw with one continuous unbroken line. Describe the features of the town as quickly as you can without stopping to see how you are doing. Then make another drawing of a distant view of your imagined town, but this time keep your eyes shut as you draw.

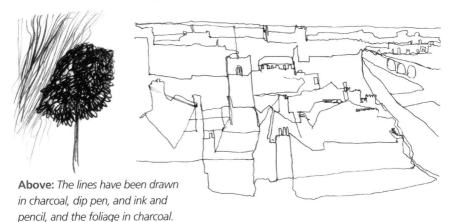

Above: *The lines have been drawn in charcoal, dip pen, and ink and pencil, and the foliage in charcoal. "Doodling" with different media is an excellent way of gaining experience.*

Above: *An imaginary town drawn in one continuous line with dip pen and ink.*

How important is line quality in a drawing?

A drawn line or stroke may be the most elementary statement, but it is nonetheless one of the most important and emotive marks in artistic impression. It is useful to practice making several strokes to investigate their potential. Far from stating the obvious, it is an exercise in working a pencil in order for you to be able to handle it, understand it, and feel through it, to create your desired effect.

It is the rapport between your hand, your pencil, and the paper that will enable you to create a physical impression of your mental image. The degree of control that you have over this facility will, in the end, affect the degree of versatility and the range of effects you will achieve – if you like, the palette of your abilities.

Before you start to make a stroke, it is important to consider what type of effect you require, because this will determine your choice of materials. For instance, if you compare a number of pencils, you will see that the leads have different qualities – hard or soft, smooth or crumbly (see page 11). These qualities will be heightened depending on the type of paper surface you use. It is important to experiment with a variety of drawing surfaces such as watercolor paper, machine-textured paper, and boards to discover your favorite materials and the right pencils for them.

> **ARTIST'S TIP**
>
> Try buying a variety of textured papers in sheet form and draw a simple area of line and tone over each, using the same pencil throughout. This will soon illustrate the influence of the surface on the range of effects that you can achieve.

Left: *The difference in the texture of pencil leads creates quite different lines. The pencil on the left has a pastel consistency and so produces a very smudgy, textured line. Similarly, the water-soluble pencil on the right has a soft lead that makes a thick line. The pencil in the center has a very hard lead, which creates a thin, consistent line.*

Why do my lines have a tendency to curve?

Once the length of your line begins to grow beyond staccato marks, it will develop a curvature. Because of the way in which the arm moves across the body from left to right, or the other way, an arc-shaped gesture results. It is therefore quite natural that long lines should follow this sweeping curved movement, and curved lines are an essential part of drawing technique, as they create a sensation of movement and depth.

Because we tend to draw the finger and thumb inward when moving the pencil from top to bottom, or alternatively pivot the hand when taking the pencil from left to right (or right to left), we again create a curved line. Curved lines are a natural development from the creation of almost static dots or very short lines, and only through conscious effort and the use of rulers do we keep lines straight.

Left: *Long fluid lines that ripple slightly convey movement and direction, but the sense of speed is slow and the feeling is one of tranquility. By varying the density and thickness of the strokes you can emphasize dimension and depth.*

Left: Judy Martin, pencil *The basic lines in this drawing give an overall impression of dense woodland. Notice how the curved lines of the branches are drawn at random over each other.*

Can I create movement and form with just lines?

Curved lines offer an added dimension within linework to create a sensation of movement and depth. They may be used in a static sense, depicting the shape of a curved surface by running in a similar direction; they may also be used individually or in small blocks, running in opposite directions to create a very complex texture.

If the width of the line remains constant, then a purely two-dimensional texture will be created. However, if this width varies from thick to thin, then the eye will not only be led around the subject but will also travel into and out of the image. This adds a three-dimensional characteristic to the simple linework.

Curved lines can also suggest movement or speed. Again, the fluctuating width of the line will substantiate the effect of moving from front to back or from left to right. Rapidly drawn, short curved lines will imply a quick movement, whereas long, gentle sweeping lines will insinuate slow, smooth movement.

Above: *By applying strokes quickly in patches of exaggerated curves, longer strokes, and shorter, slightly curved lines, a busy, turbulent pattern is created that gives a sense of movement.*

Above: *These five illustrations show the development of a three-dimensional form from a color and a shape using groups of short, straight strokes. The shape develops as layer upon layer of linework builds up the color. In each layer the lines crisscross in a similar pattern, leaving white space in areas of high color and becoming denser in areas of shadow. In the final picture a flat background is drawn in the same style.*

How can I start to understand how to "see" for drawing?

It essential to be aware of how we use our eyes in the everyday business of conducting our lives, and to discover what adjustments we have to make to our perceptual processes to successfully make representational drawings. As an exercise, perhaps at the end of an evening meal, leave the dining table and walk into the adjoining room. Then write a full description of the table you have just left. It will probably contain the following sort of information: "There are four dinner plates on the table, knives and forks, a water pitcher, coffee cups, and drinking glasses. The table is a round, mahogany table."

This first description will probably be quite limited, constructed almost as a list enumerating the various items you can remember. Now return to the room you were in. Sit looking at the table in front of you and write another description. You will probably discover quite a few things that you had left out. The reason for suggesting that you carry out both of these descriptions is simply to make you use your eyes.

The difficulty arises, however, when you try to translate this method of observation into a drawing. Most beginners find it exceedingly difficult to draw a table from wherever they are viewing it. It is impossible to see it as a complete circle, and there is a strong compulsion to visually tilt the surface so that all the objects you wish to draw can be clearly seen, as in the drawing below right. This is not caused by any lack of ability to see, but to use the information seen in a way that is not compatible with the act of drawing, although it corresponds completely with the act of verbal description.

The main problem most beginners have in perceiving the interrelationship of objects is caused to some degree by the fact that they tend to perceive the world in a solely three-dimensional way. You need to start asking yourself the right questions, through your eyes. Learn by the experience of drawing from life, and do not expect to be able to comprehend all aspects of drawing right away.

ARTIST'S TIP

Practice drawing simple objects around the home as you develop your ability to "see."

Above: *You can see from the two photographs that they have been taken from different angles. It is obvious that the photographs are of the same table, but the visual information they contain is very different. This is even more apparent when the two photographs are transformed into two line drawings.*

Left: *This pencil drawing was obviously done from memory by an untutored eye. Little attempt has been made to render the drawing with any perspective, even though the objects that were listed are all in place.*

How can I make a simple contour drawing?

The exercise that follows will require you to make a line drawing. It is what is called a contour drawing, and by following its guidelines, you will learn to "see" by improving the coordination between what you see in front of you and what your hand draws on the paper. The subject for this can be anything that is not too large or complicated. I suggest a pair of shoes, a pair of gloves, or a cup and saucer and plate. Place them on a table a convenient distance away from you, and make certain you have yourself and your board in the right position for drawing (see page 68).

Choose any medium suitable for making a line drawing, then fix your eyes at a particular point on the outline shape of one of the objects and rest the point of your pencil (or other instrument) on your paper. The point on the paper must be the same one that you are looking at in the subject. You are now going to draw without looking at the paper.

Very slowly make your eyes feel their way around the contour shapes of the objects – do not look at the paper – and equally slowly and deliberately, in pace with your eyes, make your hand describe what you see. If your hand and eye get out of step, relocate your pencil at a particular point on your drawing, fix your eyes at the same point on the contour of your subject, and continue.

Do not rub out any lines. Keep on until you have drawn the complete contours of your subject, and only then look at your drawing. If you have really followed the contours, your drawing will not be just a silhouette, because in some places your eyes will have been led inside the outline shapes to describe, for example, the rim of a cup before returning to the silhouette shape again.

It will probably take some time to produce a drawing that looks right. Your first drawing may not look anything like the subject, but it doesn't matter. Learning to feel with your eyes is what is important.

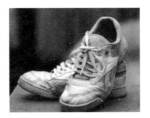

Reference photograph

ARTIST'S TIP

Reguarly practice contour drawings to improve your accuracy and ability to "see" for drawing.

Conté crayon

1 Feel your way around the contour of one of the shoes, drawing it as it leads around the object, with the sharp edge of a conté crayon.

2 Now introduce the second shoe to the drawing. Keep the line continuous, except when there is a change in direction.

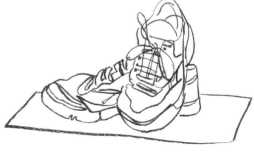

4 The complete drawing gives a remarkably good idea of the shoes, although it was done quickly and with no hesitation. You can also relate the subject to the surface beneath, by drawing in the outline of the paper on which they rest.

3 Continue the drawing, leading the contour of the second shoe back to the first one.

How can I add more detail to a contour drawing?

When people start learning to draw, they tend to concentrate on contours and ignore what happens inside them. You should consider not just the "edges" of an object but what happens in between them. To start to learn to do this, try this exercise.

You will need a cloth jacket. Stuff the sleeves with paper to make them round so that folds and creases in the fabric run around the arms like irregular corrugations as shown in the reference photograph. Now start to draw in line in any medium. Make your eyes follow the stripes or folds as they run across the form you are drawing, and use line to describe what you see. If you are drawing a garment, you will see that

there isn't a continous outline around its edge. The line will frequently turn inward to describe folds, for example, and as it does, it may provide an accurate cross section of the object.

Lines that run around forms are very important in making objects appear to be three-dimensional, and often in drawing classes students are told that they must learn to draw across forms, and not merely remain on the edge.

Reference photograph

Fiber-tipped pen

1 Use a fine black fiber-tipped pen to follow the folds and creases in this jacket. The lines describe the cross section of the garment rather than just its outline shape.

2 Draw the undulations of the folds of the jacket in much the same way as the hills and hollows of a landscape might be described.

How can I become more accurate in my drawing?

When you draw the shape of an object, you have to consider only two dimensions, height and width, but it is not always easy to make an accurate outline drawing. If your drawings are not entirely accurate at first, do not be disappointed. To be able to see shapes clearly and draw them well demands concentration and practice.

What counts most is training yourself to see. When you begin to notice discrepancies between the shape of the object and the shape in your drawing, then you are learning to draw. An effective tool in learning to see your subject is the grid method.

Grid method

Choose an object that has a handle, and other projections that make it interesting. You are going to make a drawing of your object on a grid of squares, with another identical grid placed behind it, so draw up the grids first. Mark points at 1½in (4cm) intervals along the sides of each piece of paper, and then use a ruler or straightedge to join them. If you have no convenient wall on which to pin up the grid that is to be placed behind the object, you may have to draw it on card and prop it up. It must be absolutely vertical and not turned at an angle.

Place the object on the table not more than 2in (5cm) from the grid, positioning it so that you have the best possible view of it and can see the handle or other projections clearly. Draw the shape of the object, in line only, checking constantly to make sure that the pitcher in your drawing relates to the grid on your paper in precisely the same way that it relates to the grid placed behind it.

You can start drawing at any point on the silhouette. Check where this particular point is in relation to its background square, and make sure that you start in exactly the same place in a square on your drawing paper. Continue to plot the shape of the pitcher in relation to the grid. Do not erase if you get lines in the wrong place; draw and redraw the shape until it is as accurate as possible. Then spend a few minutes comparing your drawing with your view of the actual object.

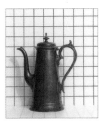

Reference photograph

Fiber-tipped pen

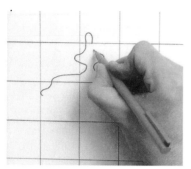

1 Use a black fiber-tipped pen to carefully draw the shape of the lid, checking it against the squares of the background grid.

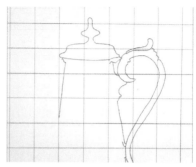

2 As you develop the drawing, continue to check the shapes against the background grid squares.

3 It is important not to change your viewpoint in any way, as this will alter the relationship of the object to the grid.

4 You may need several attempts to produce an accurate drawing. If you have to make some corrections, do not erase the earlier lines.

What is negative space?

Forms, the positive shapes in space, are revealed by the fall of light across their surfaces. Between forms lie what are called the negative shapes of the spaces. Forms and negative shapes are equally important in a drawing; focusing on forms alone deprives you of an evaluation tool, and it is only by checking the dimensions of the negative spaces against the positive forms that you can be sure they are both the required size and shape.

You can assess the qualities of space equally well by observation. Draw negative shapes as carefully as positive forms, both to affirm the dimension you give to adjacent items, and to keep control of the three-dimensional design. If you find you have made an inaccurate drawing of positive forms, examine the dimension of the negative spaces; this will highlight any discrepancies, because the two elements must match.

Reference photograph

Charcoal

1 Draw the shapes between and around the objects – the negative shapes – in line with charcoal. As you draw, remember to ignore the objects themselves, concentrating solely on the shapes between them.

2 Now block in the negative shapes, checking them as you draw and modifying them where it is necessary to do so.

3 Check again for accuracy, then shade the negative shapes darker with more precision.

4 In the final drawing, the most obviously recognizable object is the pair of scissors.

What is the benefit of drawing an object upside down?

A way of banishing preconceived ideas about an object, and learning another way to "see," is to place your object in an unfamiliar situation. In art schools elaborate groups are constructed to present familiar objects in unusual ways. This is a very valuable drawing experience, and worth trying for yourself, but you can achieve the same result by simply turning an object upside down.

It may surprise you to be told that this makes it easier to see it clearly, but you can prove it to yourself. Choose an object such as a stool, a chair, or an ironing board, or something much smaller like a plate rack; it needs to be something that is fairly complicated but with a construction that is easy to identify. First take a few minutes to draw

it the right way up in line, color, or line and tone as you wish. Then turn your object upside down on the floor or on a table and draw it again.

Do not forget the importance of the negative shapes, as they are a very useful drawing aid. As you draw, from time to time turn your drawing upside down (right way up) and see how it looks, but resist the temptation to continue drawing it the correct way up. When you have finished, place the drawing upside down (right way up) for viewing against the original drawing. Almost certainly your second drawing will be more accurate, because once the drawing is upside down you forget what the objects in it are, and concentrate on the abstract shapes.

Colored water-soluble marker

1 Start the drawing in line, with a colored marker. This color was chosen because it will later be used to describe the color of the chair. Pay attention to both the negative shapes and the abstract pattern of the chair.

2 Now use a darker marker to shade in the background and restate and strengthen some of the lines describing the chair.

3 Reinforce the crimson stripes and use a wetted brush to spread the marker ink into a wash for the background area.

4 It is easier to concentrate on the abstract qualities of an object when it is seen in an unfamiliar context or upside down, as here.

Is there a simple method of altering the scale of objects?

The size you draw objects can be very important. You may wish to focus on something quite small and make it large and monumental. At the other extreme, you may want to capture a wide panoramic view in a small sketchbook, which will involve scaling everything down. It isn't always easy to do either of these two things, because most people draw objects the actual size they see them, which is described as "sight size." Often the subject runs off the page, and another danger is that, in your efforts to keep it within the boundaries of the page, you may distort the scale and proportions.

Follow this exercise to learn a simple method of enlarging objects by eye; it may similarly be used to reduce objects in size, too. Make an enlarged drawing of something small, such as a spring clip or a toothbrush. Your drawing is to fill an A4 sheet of paper, so look at your subject carefully, and try to imagine it the size of a building that you can walk around. Start by drawing the silhouette shape quickly, and then proceed to construct a drawing within this shape that is as detailed and accurate as possible. Pay attention to the shapes of the different surfaces, and try to reproduce the shading you can see.

Conté crayon

1 You will find it easier to enlarge an object if you use a medium that makes you draw really boldly. Here conté crayon has been chosen for this quality.

2 Pay attention to the ridged pattern on the handle of the toothbrush and the shadow beneath, both of which describe the object's shape and give it solidity.

3 Seeing an enlarged drawing of a familiar object can have a disconcerting effect, and artists sometimes "play with" scale in their paintings and drawings for this reason.

How do I start to create three-dimensional form in my drawings?

The truly magical feature of drawing is its ability to create an illusion of three dimensions – height, width, and depth – on the two-dimensional surface of a piece of paper. Shading is one of the most basic ways to make objects look three-dimensional and solid.

Form is created by the light that falls on an object, so when you want to draw a solid, rounded object like an apple or something similar, look first at the way it is illuminated so that you can use shading to describe the light and shade. Look also for any lighting effects that will help you to describe its solidity.

For example, if the apple has a stem and is lit from high on the left, drawing the shadow cast onto the fruit by the stem will help to describe the dimple on top of the apple. The right side of the apple, which is in shadow, will be darker than the left, but if it is on a light surface, you may see a tiny line of light running around this dark edge. This is usually called "reflected light," which bounces back from the table onto the apple. You do not necessarily have to draw reflected light, but it can be useful in describing where the form begins to curve away.

Conté crayon

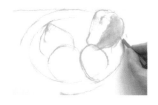 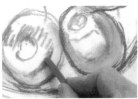

1 Draw the shapes of the fruit and the plate lightly in line with conté crayon. Then start to use shading to indicate the direction of the light, which is falling from above.

2 Describe the forms of the fruit by identifying the lightest and darkest areas. Develop the whole drawing at the same time, rather than concentrating on just one object.

3 Introduce a darker brown conté into the background and to emphasize the nearest parts of the fruit. Make the shading sufficiently strong so the objects appear solid. Draw only what you consider important; here shadows cast by the objects are ignored.

How do I handle shadows and contours on rounded forms?

To make a rounded form look really solid, you actually need to put the emphasis on the nearest part of the object. So although there may be a dark shadow beneath your round subject, treat it with caution; if you translate it as a very dark mark in your drawing, it will almost certainly destroy the sense of solidity. This is because the mark will emphasize the contour, or the outline of the fruit, which in fact is the part farthest from you, where the curvature disappears from sight. Shadows in drawings do sometimes help to describe the flatness of a table or prevent objects from looking as if they are floating in space, but they are not always helpful, as they often disguise or obscure the objects.

To learn how to render shadows and contours on rounded forms, try this exercise. Put some fruit on a table on a plain, light-colored surface such as a piece of white paper. Do not worry about the positions of the fruit as long as you can see them all clearly. The group needs to be illuminated from one side only, so if you are drawing by daylight, you may have to move your table near a window. If you are working in the evening, you can use a table lamp as your light.

Choose a drawing position that allows you to see the tops of the fruit, and using soft pencil, charcoal, or conté crayon, draw them as large as possible, paying careful attention to the way the light falls and trying to identify the darkest and lightest areas of each piece. Do not draw everything you can see just because it is there; concentrate on drawing only what makes the objects look solid. From time to time look at your drawing critically, and see whether the fruit look three-dimensional. A common mistake is to make the outlines too strong, which destroys the effect of the shading, and another is to make the shadows below the objects too dark.

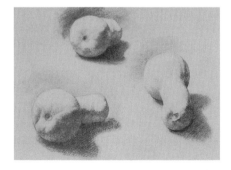

Above: *Squash studies in lamplight*, **John Houser, pencil** *This pencil drawing was done with an HB pencil, skillfully shaded and blended to describe light, reflected light, and shadows.*

How can I capture the depth of a concave object?

Once you have mastered how to capture the shape of convex objects such as fruit (see page 98), you need to tackle the problem of drawing concave objects. This is an excellent exercise to learn how to do this, and the best subject for this exercise is eggs – whole and broken. The two pieces of the shell will provide hollows to draw.

Place the eggs close together so that you can see them all and put one of the convex forms nearer to you than anything else. When you start to draw, remember which part of the form is nearest to you and be certain that your drawing explains this. Make frequent stops to check that you are getting the concave and convex areas to emerge appropriately in your drawing.

ARTIST'S TIP

When doing this exercise, do not forget to observe the shadows and reflected light.

Reference photograph

Graphite pencil

1 Pencil is a suitable medium for the delicacy of this subject. Suggest the contrast between the concave forms on the left and the convex forms on the right by the shading inside the hollows of the broken eggs.

2 Emphasize the jagged edges of the broken shells to make them project. Also use reflected light and the shadows under the broken eggs to enhance the dimensional effect.

3 The light is from the left, but concentrate less on its direction and more on the way it illuminates the convex and concave forms.

How are detailed drawings handled?

There is no rule about how much detail a drawing should contain; it depends on the type of drawing and the artist's interests. Drawings that are not intended to be works in themselves but are done as a means of gathering information may be concerned only with a single aspect of the subject, such as tone or texture. But even when a drawing is the artist's complete statement, it may not go into elaborate detail. A drawing of a figure seen against the light, for example, may contain little detail of the figure's features because they would detract from the main point of the drawing – a dark shape silhouetted against a light background.

Deciding how much detail to include in a drawing is part of the important process of deciding what to include and what to ignore. Many people, however, find it hard to make these decisions as they see more and more that could be included. Often, having tried to draw everything they can see and discovered that this led to a fussy, overworked drawing, they retreat into stopping their drawings as soon as they become interesting in case they are spoiled.

Making a detailed drawing requires, above all, patience. You must be sure that the basic shapes and the main features of your drawing are right before you focus in on details. Generally, this kind of drawing is an additive process, with visual information being added until you have created the statement you require.

Above: Martin Taylor, pencil *This pencil drawing contains an amazing amount of detail, identifying and describing individual plants and grasses as well as the various textures. Depth has not been sacrificed to detail, however, and care has been taken to get the scale of the detail right and to reserve the strongest tonal contrasts for the foreground.*

ARTIST'S TIP

When drawing detailed work, you should also give careful consideration to the most suitable medium to use. Pens, pencils, and colored pencils are all well suited to detailed approaches.

How do I capture textures?

One of the difficulties in drawing forms is that you can find yourself faced with a lot of detail and texture, and in attempting to describe this, it is easy to lose both the character and the form of the object, which can make the drawing look flat and unconvincing. Texture is important, and you will need to find ways of describing surface qualities and contrasting one with another.

Texture can also be important as a useful means of revealing form and creating a sense of depth. For example, the way the texture of an animal's fur changes over the undulations of its body gives a perfect description of the underlying form, and the lumpy, receding furrows of a roughly plowed field can give an excellent illusion of three-dimensional space.

Many things can be implied in drawings without their actually being stated. The silhouettes of objects can suggest their texture. A firm, precise shape might be used to suggest, perhaps, the smooth surface of a tomato, and a blurred edge to give a feeling of the soft fur of an animal. These devices have to be used sensitively and, equally important, experimentally. There are no formulas for creating the texture of feathers, stone, or grass; you have to look with great concentration and distill from what you see the things that seem important to you.

Just as the objects you draw have textures, your drawings contain their own textures produced by the intrinsic dualities of the materials you use. A scribbled area of pencil lines, for instance, has a duality that is different from the effect created by shading with conté crayon, or the smoothly blended tones that can be achieved by using wash. Lines also have textural possibilities that can suggest the particular qualities of objects. A pencil can produce a hesitant, soft, gray line that contrasts with the sharp, definite line of a pen.

Reference photograph

ARTIST'S TIP

Remember that you must experiment with different drawing media and with textured and colored paper.

Soft pastel

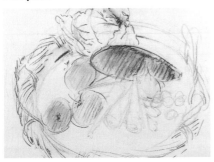

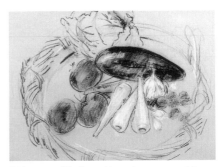

1 Working on toned paper, begin with a light application of black to indicate the positions of the fruit and vegetables in the basket.

2 Use more black, and introduce some white and off-white colors to build up the textures and tonal contrasts.

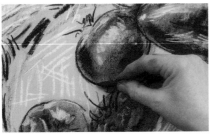

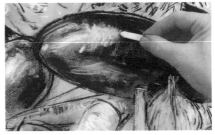

3 Describe the shiny surfaces of the eggplant by rubbing the black pastel with a finger, and then applying highlights on top. Now draw the shapes more firmly with the black.

4 Apply further highlights to the shiny surfaces of the eggplants, which contrast nicely with the rougher textures of the garlic and parsnips. Do not blend the pastel at this stage.

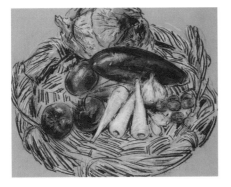

5 Excellent use has been made of the mid-tone of the paper, and the medium has been freely used to describe the contrasting textures of fruit and vegetables, and the hard, stiff basket that contains them.

Is it possible to capture textures and patterns with graphite pencils?

Yes, especially if you use a variety of hard and soft graphite pencils. The best subjects for this create contrast by incorporating both shallow and deep textures, and ordered and random patterns. Remember to increase the contrast by including some plain areas. If shadows obscure patterns or textures in the drawing, use this opportunity to keep things simple.

Below: *Pinecones*, Claire Belfield, pencil

1 Place your main center of pattern and texture interest at a point where the structural elements draw the eye to it.

2 When protuberant objects, such as the pinecones, are the decorative feature, use lighting to illuminate their forms.

3 Structures and textures that follow circular or spiral forms must be drawn correctly. Map them out faintly until you have confirmed that you are following the correct curve.

4 Use tone to heighten pattern effects. The shapes of shadows cast by complex forms, or silhouetted against a contrasting ground, are important pattern elements.

What is the process for creating texture and pattern in a drawing?

Pattern and texture create much of the surface interest on the forms you draw; if you decide to feature them, you must choose ahead of time how you will treat them. The choices range from the literal and anecdotal, which is decorative but laborious to execute, to the impressionistic, where key qualities are drawn in a simplified way. Use lighting to help you heighten or simplify effects: For example, a raking light shows up texture, and heavy cast shadows obscure large areas of busy pattern.

Choose media that depict different aspects of pattern and texture well. Pastels and carrés make crisp marks to represent the complexities of pattern, and have the breadth required to achieve a range of different textural effects. Pen work is a source of varied, expressive marks to depict texture, and has the flexibility necessary to render any patterned effect, from brash to fine. Charcoal has the advantage that it can be easily erased if you need to adjust a tricky pattern, and graphite, the perfect flexible medium, can convey both pattern and texture with subtlety.

ARTIST'S TIP

If you have difficulty deciding what to show, stop drawing and look carefully until you have devised the right response to render the effect you want.

Soft pastel

1 Draft your initial sketch minimally, to avoid loading the surface with dust. Choose paper with sufficient texture to hold the dust, but avoid the roughest surfaces unless you are content with broken cover or are prepared to push the pastels into the tooth of the paper.

2 Fix the position of the lightest tones at the same time as you draw the darkest values; they are equally important, and will establish the tonal extremes. The fall of light across objects reveals surfaces as well as form; draw major shadows in the most deeply defined textures.

3 Some textures are defined by the reflection of light on their surfaces, whereas others are characterized by diffused effects. Establish the basic colors and begin to define the patterns and textures through considered applications.

4 Do not leave out patterned surfaces, such as fruit, fabrics, or ceramics, for long; be careful to draw the pattern in perspective, particularly when it follows the circular contour of a subject. Your drawing of the decoration on a round object must curve with the form.

5 One of the artist's tasks is to devise marks that represent the different substances of which subjects are composed. Direct observation is the best method for deriving appropriate marks, so take time to study surfaces carefully before deciding which pastel effects will best show minute textures. Pastel pencils are very useful for adding details.

6 Evaluate the strength of the patterned elements and intensify these if necessary, or reduce them by tapping the surface with a kneadable putty eraser. If adjustments to the contours or perspective are required, brush off surface dust carefully with a bristle brush to clear the surface. Unless you are putting the drawing into a glazed frame to protect it, fix soft pastels lightly, or they may smear on contact.

4

TONE, COLOR, AND COMPOSITION

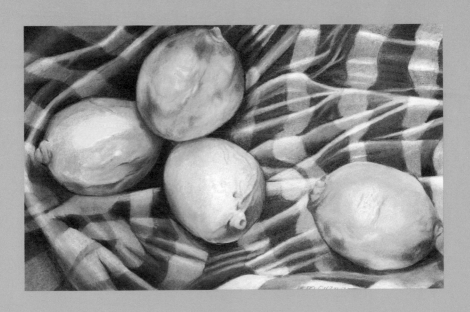

What is tone?

Shadows are cast on surfaces that face away from a light source, and the dark and light areas these create are known as tones or values. So, a dark area of the subject is described as having a dark tone, whereas a light area is described as having a light tone. Recognizing tone is an essential drawing skill, as you need to develop methods for shading or highlighting areas according to the degree of dark or light to avoid having your drawings appear flat.

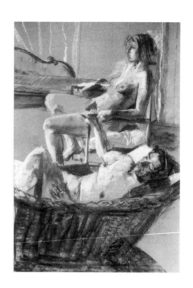

Right: Stan Smith, charcoal *This composition demonstrates a wide range of tones.*

Can I achieve a variety of tonal values using just lines?

Yes, most certainly. This can be done by applying lighter and darker pressure on your strokes, and also by placing the lines farther apart for lighter values, or closer together for darker values, as shown in the illustration.

Right: *A loaf of bread*, Valerie Wiffen, pencil *Hatching, or linear shading, will build up tonal density in pointed media. Easily graded for tonal strength, it describes curved as well as flat form by depth of tone and location.*

Heavily hatched pencil lines, drawn closely together, denote areas of darkest tonal value.

Light, spaced pencil lines create areas of light tonal value.

What is a tonal value scale?

Tones, more than color, are what give objects a three-dimensional appearance (see also page 97). A tonal value scale is essentially a shaded strip that records the tones of a subject, from the very lightest to the very darkest. These are then used to evaluate the darkness or lightness of tones when building up a drawing, whether using color or monochrome media, to create an accurate tonal range and to successfully capture the depth and volume of objects.

Making a tonal value scale

First study the subject, noting the depth and intensity of the shadows compared with the brilliance of the well-lit elements. Determine the extremes of tone, then begin to note down their relative positions on your scale, thus setting the limits of the tonal range in the drawing. All other variations in tone must be graded between these two poles. Continue to plot the other tones of the subject on your scale.

Pay special attention to the lighter areas that are sometimes reflected on the shadowed parts of forms. Your brain tends to interpret these as lighter than they are, making it easy to allocate too light a tonal value to them. Because they are in a shaded area, they are lighter darks, and cannot be as pale as the values in the light.

Left: *It is a good idea to experiment with the full tonal range of various media. Draw a tonal value scale like this and see how many different tones you can achieve.*

Below: *Gravyboats*, **Sarah Adams, pencil** *Distinctive tonal changes on glazed or metallic surfaces can be represented subtly, by creating tonal strengths with carefully graded areas of tone. Removing your hallmark style can also create an almost photographic effect.*

Why and how should I tone my surface?

Toning eliminates the stark white of the surface and creates a unity that will underpin your drawing. It is also useful in establishing a range of tonal values, and is most commonly used with charcoal (see page 31). Use the side of the stick to make a consistent gray background, then use the tip to put in "positive" details. Use a kneaded putty eraser to pick out lighter, "negative" areas and highlights.

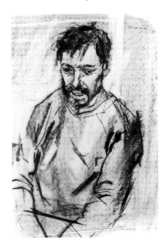

Right: *Male portrait*, Stan Smith, charcoal *Charcoal is particularly suited to this technique.*

How do I make a tonal drawing?

A tonal drawing will enable you to investigate the tones in your subject and create a faithful recording from which you can later work. A good way of starting a tonal drawing is to draw the main shapes, then decide the tonal limits of the subject – which are the lightest and darkest areas (see page 109). Decide next how many tones to have between these limits. There may in fact be many slightly different tones to be seen in the subject, but usually it is necessary to reduce these to two or three so that there is an adequate balance between contrast and harmony. Once the tonal framework has been decided, draw the tones within it and change them if they do not look right.

Above: *The varying tones can be clearly seen in this tonal drawing for a painting where the pattern of light and dark will play an important part.*

What are the properties of color?

With many subjects, what you notice first about them is the color. You have only to think of a landscape or a seascape, for example, to recognize how important the color is, and it is often this most of all that makes you want to re-create what you see.

Any color has three basic properties – its hue, its tone, and its intensity. Hue means the color as identified by its name – red or blue, for example. Tone means the lightness or darkness of a color. You can, for example, have a light blue or a dark blue. In addition to the properties of hue and tone, colors have varying degrees of intensity. Two reds may be identical in tone and yet be clearly different, with one more intense, or brighter, than the other. This difference in intensity is sometimes called color saturation or chroma, but here the term *color intensity* will be used.

When you use the word *color*, you are generally referring to these three properties – hue, tone, and intensity – simultaneously. However, it is helpful to be able to identify them separately, because when you notice that a color is "wrong," you will be better able to pinpoint what is wrong with it – whether it is too light in tone or too intense.

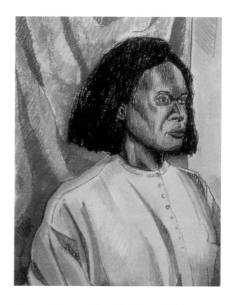

Above: *Blue and gold*, Richard Kirk, pastel and colored pencil *This drawing defines the properties of color well. For example, the hues are clear and not muddy; the blue tones in the curtain vary from light to dark blue, and the intensity (brightness or dullness) in the sweater differs between the highlighted and shadowed areas.*

How does light affect color?

Color is an effect of light. The range of colors that we see in a given context depends upon the quality of illumination created by the available light, but the color is a real phenomenon, not an illusory or transient effect. Each material or substance that we perceive as having a particular color is reflecting certain light wavelengths and absorbing others, and its ability to do this is inherent. A red object, for example, does not suddenly turn blue under the same light conditions, but it will not appear red if it is not receiving illumination that includes red light wavelengths.

White light contains all colors, and it is under white light that you see what might be called the "true" color of an object – what artists call local color (see page 113). The spectrum of white or colored light is estimated to include about 200 pure hues within the visible range, although not all are readily distinguishable by the human eye.

For the artist the practical points at issue are the visual sensations of light and color, and the ways in which these are experienced. Colored surfaces that are solid and textured behave quite differently from colored light. Because white light is composed of colors, a certain combination of colored lights makes white, but with drawing or painting materials, the more colors that are applied, the more colorful or darkly veiled the surface effect becomes. The artist is dealing with substantial elements, and must learn how they can be used to create equivalents of the insubstantial effects of light.

Right: *The pigmented representation of the light spectrum illustrates the colors that result when a beam of white light is split into its component parts.*

How do we see color?

We see color in physical terms by the action of light on the rods and cones in the retina of the eye. The cones distinguish hues, whereas the rods register qualities of lightness or darkness.

By some estimates, a person with normal color vision is capable of identifying up to ten million variations of color values. The conditions known as color blindness include several forms of incomplete color

perception – an inability to distinguish red and orange hues from yellow and green is perhaps the most common – and there are rare cases of people who see only in monochrome.

However, none of us can be sure that we see colors in exactly the same way as anyone else. It may be possible to measure the color range of light entering the eye, and to check the efficiency of the physical receptors, but this says nothing of the sensation of color experienced by an individual. Our responses to visual stimuli are "processed" by the brain, which can add memories, associations, and its own inventions to the purely physical information we receive.

What is local or key color?

The local color (also known as the key color) of an object is its actual color seen in natural light – or to be absolutely precise, the color it reflects. If you look carefully at any object, however, you will see the local color only in small areas, and sometimes not at all, as it is modified by the light and shadow and by the distance of the object from you.

To explain it more simply: Any object strongly lit from one side ceases to look as if it is a single color. Although the shadow side and the light side have the same local color, they look completely different. If you take two pieces of identically colored paper and place one close to you and the other on the opposite side of the room, you will also find they look different; the more distant piece will be less intense in color.

One of the problems facing you when you begin to deal with color is to make the colors you see consistent with the local color. Most inexperienced artists try to imitate the actual color; they know a lemon, for instance, is yellow, so they ignore the fact that parts of it may be green or brown. Others exaggerate the colors they see, losing sight of the yellowness altogether.

Above: *First Ade*, **Vera Curnow, colored pencil** *Everyone knows lemons and limes are yellow and green; these are their local colors. However, on closer inspection, the artist will see the red, orange, and tan hues in the shadow of the lemons, and blue and violet hues in the limes, along with reflective colors from any neighboring objects.*

What is a color wheel?

The color wheel is simply a graphic device for explaining the basic relationships between colors, based on the relationships between primary and secondary hues. Placing the colors within a segmented circle gives an arrangement in which each primary color faces, in the opposite segment, a secondary that is composed of the other two primaries. By going around the wheel you can identify the relationships of adjacent or harmonious colors, and by working crosswise you can see the opposing pairs of primaries and secondaries known as opposite or complementary colors (see page 116).

Primary colors
The primary colors are red, yellow, and blue. These cannot be made by mixing other colors, but all other colors can be created by mixing the primaries in different proportions.

Secondary colors
Mixing the primary colors together in equal proportions produces the secondary colors, orange (from red and yellow), violet (from red and blue), and green (from blue and yellow).

Left: *The color wheel was devised to explain graphically the relationships of pure hues, showing the three primaries – red, blue, and yellow – linked by the secondary color mixes – violet, green, and orange. Adjacent colors are harmonious; opposite colors are complementary. This example is constructed with strokes of pastel color: It shows the circle of pure hues and also tonal variations from light values in the inner ring to darker tones on the outer border.*

What is color contrast?

Different color effects are produced by the way that colors contrast with each other. Colors are often arranged around a circle, called a color wheel, starting with red and proceeding in steps through orange, yellow, green, and blue to violet (see page 114). The greatest contrasts are between colors opposite each other on this circle, for example red and green. These colors, called complementary colors, provide the maximum excitement for each other, and can set up definite discords. Colors that are harmonious are those next to each other on the color circle, for example, yellow and orange, blue and mauve.

What is color temperature?

Colors in the red, orange, and yellow range are generally seen as warm, whereas blues and greens are considered cold. Generally, warm colors appear to advance to the foreground and cool colors recede into the background; they can therefore be used to create a sense of depth in your drawings. However, this cannot be taken as a firm rule; if you have an intense blue in the foreground and a muted red in the background, for example, the intensity will compensate for the tendency of blue to recede.

Something you will probably begin to notice is that the colors of shadows tend to be cooler than the light-struck areas of an object, and using blues or greens in the shadows will help you make them look solid. You will also see that the colors in the background are cooler and less intense than those in the foreground, and if necessary you can exaggerate this.

Above: Elizabeth Moore, soft pastel *The drawing has a good feeling of depth, partly because the background colors are cooler than those in the foreground. Blue can be a "recessive" color, but in this case its vividness is accentuated by the striking contrast with the yellow.*

Why do we mix color?

The color you see in an object is not a flat tone but a combination of several colors juxtaposed and interacting with each other. Look at an object carefully, such as a white coffee cup. If you study the different parts of it closely, you will see not just white and gray, but yellows, blues, and even pinks. An object colored with little tonal variation does not convey as much sense of form as one in which the tones are heightened. We therefore need color in varying tones to see form (see page 118). Any shape you see is a shape of color, created by that color – it is not simply an outline that is "colored in." Therefore without drawing with outlines it is possible to construct a colored object that looks realistic.

Advancing and receding colors
Right: *A color's power and its visual dominance are often a direct result of its surrounding color and what the human eye relates it to – if you like, its color context. It is also affected by its volume or area. The panel illustrates five pairs of colors in reversed positions to show how area and context affect the feeling of a color, making it advance or recede.*

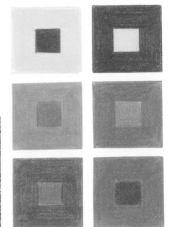

Juxtaposed color
Below: *The yellow-green background acts as a foil to the orange, making it jump forward, whereas the black kills the vibrance of the same orange color.*

How is color mixed?

Many drawing students are reluctant to begin working in color because they anticipate difficulties. In practice, making colored drawings is easier than most people expect it to be; in monotone media, you are obliged to allocate a tonal value to each color in order to represent it, but in color, you simply draw what you see. Mixing colors to match observed values becomes less daunting when you choose a palette with sufficient range to create all your required shades.

In most painting media, the colors are premixed and applied to the working surface, but in most colored drawing media the colors must be mixed on the surface itself. A relatively small range of colors is needed for premixing in painting, because the permutations that are possible create many variations of hue (see page 111). The surface mixing required in dry drawing media is less easy to accomplish.

Because such linear media make narrow marks, you need to adopt an accumulative technique, such as hatching or crosshatching, to build up a body of color. Strokes applied separately will be seen as a composite shade at a distance. Overlaying color creates mixtures, too, and this can be built up to strength gradually. Experiment beforehand to discover the colors that result from changing the order of application: For example, applying blue over crimson creates a purple that is different from the one that is made with crimson over blue.

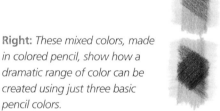

Right: *These mixed colors, made in colored pencil, show how a dramatic range of color can be created using just three basic pencil colors.*

ARTIST'S TIP

Complicated color mixtures can be dulled by the traces of hidden colors they contain, so to be truly effective, keep blends as simple as possible.

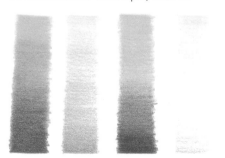

Left: *Two sets of color gradations – warm yellow to red and warm yellow to blue – are shown. The left-hand column in each set was achieved using considerable pressure on the pencil, and the right-hand column was created using very little.*

Suggested palettes

A good palette for making premixed colors in either inks or washes consists of opaque white, for lightening and creating pale shades, unless you use diluted transparent colors for this; mid-yellow; orange-red, for making orange and light browns; crimson red, for mixing mauves and purples; warm, dark brown, as a mixing base for browns; cool mid-green, as a similar base for greens; mid-blue, usually called cobalt, that makes turquoise when mixed with green; warm, dark blue, usually called French ultramarine; and black, both as a color and to make greens with yellows, and browns with reds.

This list should be expanded for dry-mixed media, so that you can create rich shades without making them muddy. Add dark earth yellow; strong orange; dark earth green; ready-made purple; cold, dark brown, leaning toward green; and warm and cold grays.

What is a good introduction to identifying the tones of colors?

By not recognizing and interpreting a color's tonal value when you draw, your subject can appear flat (see page 116). A good way to check the value range of your subject before you begin to draw is to create a monochromatic collage. Try this exercise as an introduction to translating colors into tone. Instead of building up tones as you work, you will be using dark, gray, and white pieces of paper, which are cut in small pieces and stuck onto your working surface.

Use papers in a range of not more than five colors. Work on off-white paper, which will provide the fifth tone. When you do a "normal" monochrome drawing, the number of tones you can use is wide, extending to possibly ten or more. When you are restricted to a certain number, you have to look closely

at your subject and figure out which tones are the most important.

Start by making an outline drawing in pencil, then identify the most dominant shape and tone in the group, and match this as closely as you can to one of your papers. Once you have the darkest tone in place, you will have a key for the rest of the drawing. Find the lightest area of tone next, and put some white pieces of paper in place, then start to build up the middle tones gradually until you have described each object.

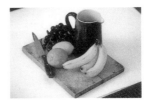

Reference photograph

Graphite pencil and colored paper

1 Draw the main shapes of the still-life group in pencil to act as a guide.

2 Identify the darkest shapes, then cut out and stick down appropriate shapes. If any shapes or tones look wrong later on, they can easily be corrected by pasting additional pieces on top.

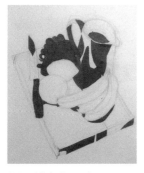

3 Establish the main pattern of dark tones; the "drawing" begins to take shape.

4 Paste the lightest tones over the mid-gray paper, which stands as a middle tone, and add a dark gray for the knife.

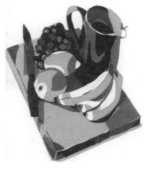

5 Having to define and translate tones in this way often produces a clear, powerful drawing, as in this case. Cut-paper drawing, or collage, is exciting to do as well as a useful preparation for color work.

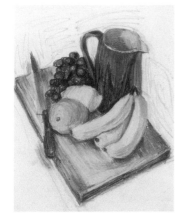

Left: Karen Raney, oil pastel *The completed drawing maintains the tonal contrasts identified in the exercise above.*

How do you capture emotion with color?

Color can be used to convey a mood. The associations that colors have are apparent from our everyday speech – we talk about "seeing red" and "feeling blue." Such phrases are not reliable guides to the emotional properties of colors: Red, although certainly an assertive color, is not necessarily an angry one, and blue is now widely believed to have a calming effect rather than a depressing one. However, the way colors are used and juxtaposed in a drawing can be very expressive. Dark, heavy colors create a somber mood, whereas light, bright ones give a carefree impression, and violently clashing colors can give a feeling of restlessness or unease.

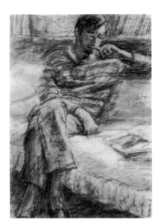

Above: *Mike reading*, Tony Coombs, charcoal *Subtle tones are created by softening the drawn charcoal marks, making an evocative image.*

What are the basics of composition?

Composition is the art of combining the various elements of a drawing (or painting) into a satisfactory visual whole. In a good composition the various shapes, forms, and colors (if color is used) are arranged so that the work continues to hold the viewer's interest after it has made its initial impact. The drawing must be contained within a shape, usually a rectangle, of appropriate proportions and size, and the various dynamic forces created within this shape must be held in equilibrium. When you look at a well-composed drawing, you should feel that its composition is not weighted in one direction or the other, but that everything is held in balance.

Compositional approaches
There are two main ways in which you can approach composition in drawing. The first is to draw without being concerned about the shape the drawing will finally take, and only as it nears completion, decide on the best proportioned rectangle or shape to

contain it. This can be done by masking off your drawing with strips of paper, or two L-shaped corners cut from card or paper, until you are satisfied that you have the best shape.

The second approach is to treat the rectangle itself as the starting point, and compose your drawing within it. If you are making a drawing for a painting, you may have a particular size in mind for the picture, and so the drawing needs to have the same proportions. In the history of art many drawings and paintings have been based on simple geometric designs. The drawing rectangle was divided in particular ways, and the main features of the composition made to conform to this predetermined design. Many compositions, for example, are based on a triangle, with the base at the bottom of the paper and the point at the top. However, it is more usual today to draw by trial and error, composing the drawing as you work, and using your judgment to decide what looks right.

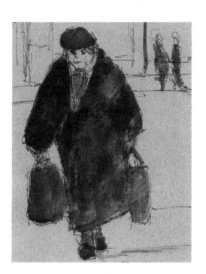

Above: *The shopper,* John Denahy, pen and wash *In this drawing, the overall compositional shape is a triangle, placed in the rectangle with its apex left of center. This is balanced by the background figures set within an inverted L-shape.*

Left: *First term in the life drawing room,* Paul Bartlett, pencil *This unusual pencil drawing is a vertical composition and gives an excellent impression of the narrow view you often have as you look between the other students in a life studio. The foreground hand and the side of the drawing board direct you toward the model, but these directional forces are balanced by the many near-horizontal lines.*

What is the "Golden Section"?

The Greeks devised several ideal standards, the most well known of which is the Golden Section, also known as the Rule of Thirds. Here a line or rectangle is divided into two parts so that the ratio of the smaller to the larger is equal to the ratio of the larger to the whole line.

This ratio (approximately 8:13) has been known since antiquity and was believed to possess inherent aesthetic virtues, bringing art and nature into harmony. Although it is considered less important today, it is interesting to note that many drawings and paintings, when analyzed, reveal the use of this proportion even though the artists concerned did not use it consciously.

It appears that we tend naturally to divide the drawing rectangle in this way.

The fundamental rule of composition is that the picture surface should not be divided symmetrically. This basic rule of asymmetry in composition can be extended to provide further rules. For example, it is courting disaster to place a standing figure in the center of your paper, or position a fence so that it runs horizontally across your drawing, equally dividing the distance from the bottom edge of your drawing to the horizon line. There are, however, no rules that cannot be broken, and artists do sometimes make symmetrical compositions work well.

Above: *Ascribed to Euclid, the Golden Section was held by the Greeks to be the ideal division of a surface. To find the section, divide the line AB in half at C; draw a radius from the top right-hand corner of the cube to create D. In the drawing second right, lines have been drawn to create a rectangle, point BG forming the vertical section. To find the horizontal section, shown in the drawing at far right, draw a line from the top of the vertical G to the bottom right-hand corner and a radius from the top right-hand corner downward. The line and arc intersect at the level of the horizontal section.*

Right: *Hungerford Bridge*, **Ian Simpson, pen and wash** *No definite shape was chosen in advance, but the rectangle the artist eventually decided on shows that the far bank of the river and one of the bridge's strong verticals divide the drawing into Golden Section proportions.*

How do I determine the focus of my drawing?

Focus is concerned with the process of selection by which you determine how much or how little to represent in detail, allied to the depth of the whole drawing. As well as showcasing the parts of the drawing that you want people to notice, you will need to suppress less important ones, partly by developing the elements of maximum impact in full detail. This draws attention to the details as the eye is drawn naturally to highly worked areas; the simpler parts are needed as a contrast to the busy elements, and will be viewed with less intensity.

Decide which areas to work up and what to treat broadly by consulting your sketches and choosing where you want to center interest. Look at the directions of the lines in the layout and, because distance obscures detail, consider the three-dimensional depth of the picture. You can also focus attention by slightly increasing the tonal contrast in the chosen area: Brightening the light values and strengthening dark tones draws the eye to them. Make sure that these adjustments are subtle, and avoid overemphasizing contrasts, because this will upset the tonal scheme and cause changes in the perception of space within the drawing.

ARTIST'S TIP

Decisions about focus are personal, so develop the qualities that hold most fascination for you, subject only to the safe procedure of working broadly at first and defining details later.

What shape should I use for my picture plane?

There is no reason why a drawing should not be planned within a circle or oval, but the majority of drawings are rectangular. These shapes, depending on whether they are horizontal or vertical, are usually known as "landscape" or "portrait" format respectively. Traditionally, these subjects have been drawn and painted in these particular shapes, but they do not have to be; an upright landscape can be very effective when you want a composition with a vertical emphasis. What is important is that the shape suits the subject.

Above: *The brothers*, David Carpanini, pencil *The oval format of this pencil drawing echoes those of the heads of the standing men. The horizontal provided by the terraced houses, together with the lines of the roofs and angular shapes of chimneys, serves as counterpoint to the curves and repeated ovals.*

Above: Kay Gallwey, fiber-tipped pen and water-soluble pencils *Two drawings have been joined together to give this a wide-angle landscape format that suits the subject of the piece.*

Does the subject have to be completely in the picture plane?

Until the mid-nineteenth century, the conventions of composition required that the main interest in a picture be entirely contained within the picture rectangle. No vital element was cut off at the edges of a drawing or painting. The advent of photography brought about important changes in how composition was seen. "Snapshot" photographs sometimes cut off people and objects in strange ways, and artists began to experiment with similar effects. Dramatic effects could be obtained by "cropping" a figure or object, and artists also found that other photographic effects could be useful, such as having part of a picture indistinct and out of focus, which could add to its sense of depth and drama.

Cutting off objects at the edges of drawings can have the effect of bringing the viewer into the scene, and sometimes can create an illusion of events existing outside the limits of the drawing. Part of the process of selection is to decide where the outer edges of your drawing should be and how they should contain the subject. If you are cropping an object or figure, consider the way the edges of the drawing rectangle cuts across them; if the cropping is awkward, the composition can look casual and unplanned.

Above: Diana Constance, pastel *Here the artist has chosen a close view to make an interesting composition. The joined arms and the upward-thrusting knee make the composition complete even though much of the figure has been omitted.*

Left: *Head study*, Robert Geoghegan, pastel *The form of dramatic composition and cropping seen in this study is more often associated with photography than with drawing.*

What is the advantage of drawing thumbnail sketches?

Thumbnail sketches are an essential starting point for any decisions on composition, from the points of view of both form and color. Explore the possible variations by altering the amounts of background or foreground included, and by placing the focal point of the work at the left and right side of the composition.

Although the subject matter can be important in making an interesting drawing, it is more important that the position of the subject within the sides of the picture plane make an interesting composition, and thumbnail sketches will help you find the best solution.

Left: *In this thumbnail sketch the verticality of the vase of flowers is balanced by the horizontal expanse of the window.*

Left: *Here the artist decides to use the angles of the corner of the room and the table in contrast to the cylindrical form of the vase.*

Left: *By taking a viewpoint farther back and bringing in the edge of the table, below, the centrally placed vase is integrated more fully into its environment and the composition.*

Above: *By cropping in on the sides and emphasizing the vertical feeling of the image, the vase of tulips is made to dominate the composition.*

What are some tools to convey the illusion of three-dimensional space?

There are many compositional tools that will help you convey the illusion of three-dimensional space. The most useful give visual clues that the viewer associates with an experience of real space, and are usually simple.

The first technique is perspective, which creates apparent recession by arranging items vertically in the picture while diminishing their scale (see page 128). Essentially this relies on the understanding that distance makes elements and the spaces between them appear smaller. This particular illusion is more convincing if you overlap items, because intervening objects often obscure distance in reality.

Semicircular alignments also have a role; by selecting them for emphasis, you can use them to move the eye from one stopping point to another, across and through the span of a drawing. Vertical forms provide punctuation points among the horizontals, and also appear to diminish with distance. Draw them shorter, and reduce the spaces between them. Remember that anything vertical to the picture plane must be drawn upright; a slope creates an illusion of falling.

Right: ***The Graig***, **David Carpanini, charcoal** *Here, what might at first seem to be a rather bleak view is transformed into a powerful, vivid drawing by the use of the different perspectives. The angle of the rail in the left foreground becomes the sweep of the road in the distance, dramatically broken up by the telegraph poles, while the rails, hills, and clouds on the right pull the viewer toward the row of houses.*

Vertical forms punctuate the horizontals.

Clouds reinforce the vertical perspective.

Semicircular marks move the eye across.

What are the basic principles of perspective?

If you observe carefully and draw exactly what you see, you can make convincing drawings of objects without knowing anything about perspective, but some knowledge of the rules is helpful. The word *perspective* is used in relation to life in general. The phrase *putting things in perspective* means deciding the relative importance of things, and in art, perspective is a method of depicting objects in the correct scale and relationship to each other.

In the long history of art perspective is a comparatively recent discovery. It emerged in Italian art in the fifteenth century, when the Florentine architect Filippo Brunelleschi (1377–1446) found that there were mathematical laws that governed the way that objects appear to diminish in size as they recede. It soon became the method used by all artists to create three-dimensional effects in drawing and painting.

In a sense perspective has always been there, but it was only when artists became intrigued by the accurate measurement of distance that it could be discovered. The simplest way of illustrating what was originally interpreted in mathematical terms is to look at a rectangular doorway, first closed, then open, as shown in the images below. Now consider a further visual fact. If you look again at the open door first from a sitting position and then standing, the door will change its shape as you change your position. These simple exercises in observation illustrate the basic principles on which perspective is based.

Left: *It is easy to underestimate the effect of perspective. It is the old problem of being unable to discard preconceived ideas; we know that a door is rectangular. You may find it helpful initially to hold up your pencil and tilt it to assess the angle. Also check the negative shapes – the space you can see at the top, bottom, and side of the door.*

What is a vanishing point?

When receding parallel lines drawn along the top and bottom of an open door (see page 128) would, if they were extended, meet at a certain point, this is called the vanishing point (VP for short). It is always at the level of your own eyes, often referred to in books as the "horizon line" or simply the "horizon."

VP Horizon line

Horizon line VP

Left: *If you are drawing a simple object in either parallel perspective or angular perspective, you may find it helpful initially to mark in the vanishing points as shown.*

What is a fixed viewpoint?

As you move, your perspective changes. To really understand this, try this simple exercise. Look out through a high window where there are buildings both nearby and some distance away, and trace the main lines of the view onto the glass. You could use a wax crayon or paint and a small brush, but you can still get the idea if you simply trace on the glass with a wet finger. You will find it impossible to trace the view accurately unless you close one eye, and as soon as you move your head, the objects you are tracing will move in relation to your tracing on the glass.

To put it simply, perspective relies on a consistent, or fixed, viewpoint, placing your picture in the position of the window, and imagining having a single eye and your head fixed in one position.

Left: *These diagrams show clearly what happens when you move your viewpoint even slightly. If you look at something with one eye closed, and then open that eye and close the other, everything appears to shift to the right or left.*

What is parallel perspective?

The ground on which the artist stands is known as the ground plane. His eye level will depend on its relation to the ground, in other words on whether he is standing or sitting. His perspective of the subject he is drawing will depend on its relationship to his eye level, on whether he is looking at the object from above, below, or the same level, and on the angle at which it is placed.

The center line of vision is an imaginary perpendicular line that is drawn from the artist's position to the horizon line, meeting it at right angles. If the artist is facing his subject full on, then all receding parallel lines will appear to converge at the point on the horizon line where his center of vision strikes it. This is the most simple form of perspective: parallel perspective.

Left: *The effect of the parallel lines appearing to meet at a vanishing point is seldom quite as obvious as in this frontal view. Often you will have to cope with bends or irregularities at the edges of a path, or it may be running slightly up or down hill, which affects the level of the vanishing point.*

What is angular perspective?

The limitations of parallel perspective made it impossible to depict corner-on views of objects. For views of this kind angular perspective was developed where, for example, two sides of a building that are actually at right angles to each other can be drawn receding to separate vanishing points.

Angular perspective has to be developed before angled views can be drawn. To understand how this works, arrange six or more books of any size so that they are all corner-on to you,

with some at an angle on top of others. Make a drawing of their shapes from observation. You may be able to use the edge of the table as a reference, or you could stand something on the table near the books to provide a vertical for comparison with the receding sides of the books.

When you have drawn the books as accurately as you can by eye, draw in your eye level and extend the sides of the books until they meet. If any of the books are parallel to each other, each

pair of parallel sides should meet at the same vanishing point. Otherwise each book will have two vanishing points, but they will all be on the same eye level.

You will need to extend your paper on both sides at the eye level to check where the receding lines meet to form vanishing points.

Colored pencil

1 With the books placed corner-on, assess the angles without the help of any horizontals. This is considerably more difficult than drawing objects in parallel perspective.

2 Even when you are drawing what may seem a dull subject, the way you use the medium can make the drawing interesting. Here the colors have been selected as complementaries to give the piece a pleasing, vibrant feel.

3 Add another sheet of paper to the drawing so that you can extend the eye level, and check the vanishing points for the receding sides of the books. A sheet added to the other side of the drawing would enable the other sides of the books to be checked also.

What is foreshortening?

As seen in the basics of perspective (see page 128), when the door was opened, it ceased to be a rectangle and became an irregular straight-sided shape, with the vertical edge at the back shorter than at the front. As objects become farther away from you, they become smaller and smaller, until they disappear altogether on the horizon. This optical shrinking is known as foreshortening. As well as getting the receding lines of an object correct in a perspective drawing, you also have to get the right amount of foreshortening.

Usually this is judged by eye, but foreshortening involves a fundamental problem. Nearly always, when objects are drawn from direct observation, the extent to which they are foreshortened is underestimated, because you fail to see how much smaller they become when pushed back in space. You must draw what you see and not what you know about the subject. We all know that arms are long enough to reach the middle of the thigh, but if the arm is bent and reaching forward, it will be foreshortened.

What is aerial perspective?

This type of perspective increases the illusion of depth by concentrating on the atmospheric conditions between the observer and subject. The basic idea is that objects that are close up will retain their full color and tonal values and be clearly identified, whereas distant objects have their tones modified by the atmosphere. This effect can be seen best either toward evening when the light is beginning to fade or on misty days.

Try capturing aerial perspective in a drawing by finding a convenient view from a window where you can relate distant and close-up objects. A view from a high window looking down at your yard or across rooftops would be an excellent subject for this exercise. Look at the way that tonal contrasts are less and less distinct the farther they are away from you. Use line as little as possible (ideally not at all), and translate what you can see into a tonal drawing using conté crayon, charcoal, or wash. You can include color in your drawing if you wish, which will help to create a feeling of depth through the blueness of distant color.

Charcoal

1 Using charcoal, start by establishing the positions of the chair and the window behind it.

2 Now strengthen the drawing of the chair, which is the most prominent foreground object.

3 Shade in the large areas of tone by using the charcoal flat on its side.

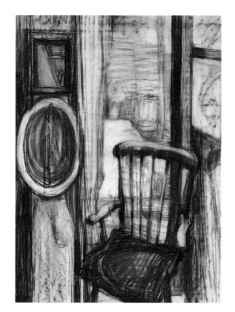

4 In the final drawing a sense of depth has been created by the strong tonal contrasts in the foreground. As you look out through the door and down the path, the contrasts become less distinct and less clearly defined.

CHAPTER

5

WORKING ON LOCATION

What is the advantage of working in a sketchbook?

Sketchbooks are invaluable for working on location; in them one can record everyday incidents, color notes, figure studies, and ideas for compositions. In a sketchbook the artist can make mistakes to resolve problems in serious art.

Quite often the artist's most interesting work will be found in his sketchbook; the small sketchbooks used by John Constable (1776–1837), for instance, reveal a wealth of location detail in terms of cloud studies, light effects on the landscape, and details of artifacts, such as farm wagons, all of which he used as reference for larger paintings.

Every artist needs to get into the habit of drawing frequently from observation, and you should sketch daily even if only for three or four minutes. Quick drawings are important, as you have to sum up your subject rapidly and draw what seems important. This will naturally greatly assist you in establishing a strong composition.

What size sketchbook should I use?

Sketchbooks are available in different sizes, with various bindings and different kinds of paper. Do not choose too small a sketchbook; an A2 size will give you plenty of room for making quite large drawings, but is usually too large for conveniently taking everywhere. If you buy an A3 size with a sewn binding, you can open it out, and make large drawings across two pages when you need to.

Left: *Sketchbooks are made in all surfaces, many sizes, and both portrait and landscape formats. Pocket-sized books can be carried everywhere but may cramp your style when tackling larger subjects. Big sketchbooks are tiring to hold, but offer adaptable space, with the option of making several small studies on a single sheet of paper. If you intend to use washes in your sketches, choose a book with heavy paper or paper with plastic-bonded edges – unsecured light sheets will buckle and wrinkle.*

What other equipment do I need for working outdoors?

Depending on the medium you choose, you may need a few extra items besides your sketchbook. In the first instance consider taking a bottle to carry water for thinning ink or paint; this can be carried in a plastic mineral-water bottle or something similar. You will also need a plastic carton to pour some of the water into for use. A bag of some kind will be needed to carry your drawing materials, and depending on where you decide to go, a folding stool may be useful. Also take warm clothes; even on warm days it can be cold drawing outside because you are not moving around.

This might be the point at which to consider buying a sketching easel. These are light and reasonably portable, and are perfectly suitable for indoor use as well. If you have a friend who draws or paints, try to borrow their easel to try, or if you go straight to a store, set up the easel while there to make sure that it suits you, is a size and weight that you can carry easily, and will hold your drawing board satisfactorily.

How do I handle working outdoors?

The thought of drawing and sketching in public may initially make you feel apprehensive – perhaps you dislike the idea of dealing with inquisitive people who come and look over your shoulder – but these problems can be overcome.

If you can find a sheltered spot, you can work outdoors for most if not all of the year in most countries. Rain is a greater obstacle than cold, and although nosy people can be a nuisance, working in a sketchbook is a relatively private way of working. In any case once you start, you will be so engrossed in what you are doing that you will be unaware of passersby, and they probably will not notice you.

Working outdoors is an exciting experience. In particular, drawing and sketching on the spot puts great pressure on you to work at speed. Even on days when the weather is reliable, the light changes constantly, and if you are including people in your piece, they will move before long. But because you have to work quickly, all kinds of things can happen in your drawings that you may not be aware of until you get home.

ARTIST'S TIP

Chance happenings often produce better drawings than a highly controlled approach.

Where and when should I sketch?

You can sketch in the studio, but it is no hardship to take your sketchbook with you practically wherever you go. Any long journey, or a business trip, provides the opportunity to sketch unfamiliar places and people in time that might otherwise be wasted. This is valuable for simple practice in sketching technique, and also forms an interesting personal record of where you have been and what you have seen.

> **ARTIST'S TIP**
>
> Use a small sketchbook and a simple tool such as a fiber-tipped pen to make quick visual notes.

Confronted by so much potential subject matter, how do I choose what to draw?

Once you have decided where to draw, you will find the first problem is what to draw. Working outdoors you will be confronted with a wide choice of views and objects. This is the purpose of the preliminary studies or thumbnail sketches (see page 126), which will help you decide what will make the best subject. Ignoring things that you see, or inventing things when your view of them is obscured, are difficult tasks and should be avoided. To avoid drawing something, move it or find another position from which to work.

Viewfinders

A viewfinder, a piece of card with a rectangular hole in it, is a good aid to get you started with deciding what to draw, as it will help you select a small part from a complex subject.

Left: *A temporary viewfinder helps select a viewpoint on location.*

Left: *Make a durable viewfinder from heavy cardboard. Glue together three layers for each piece, with the central layer of each side piece narrower; to form a groove. Tape the top and sides together, and leave the bottom piece loose to slide up and down.*

What information should I include in a sketchbook?

You should include any details, colors, or impressions that will help you remember the scene when you are back in your studio. In the examples shown here, the uncompromising vertical and horizontal lines of this office building appealed to the artist, so he decided to record them as a sketch for reference later. He worked very quickly, eager to establish the broad areas of the drawing in colored and graphite pencils, handling them loosely and freely in order to get down as much information as possible in the short time available.

Left: *The artist works in pencil, drawing what he sees but simplifying the forms so that he can record his impressions quickly but accurately. He was attracted by the strong verticals and horizontals, and he makes these a feature of the sketch.*

Above: *The artist records everyday events, makes notes of subjects that interest him, develops ideas, and solves problems in his sketchbook. Here he addresses himself to a subject that might easily be overlooked but that is important to all city dwellers.*

Above: *He uses a few colored pencils to record local color. This will be useful if he should decide to use this subject in a painting.*

Above: *He applies the color to the piece with freely handled parallel strokes.*

Above: *In the final sketch blue has been scribbled into the sky, and this time the color is laid on much more loosely with strokes that vary in direction.*

Left and above: *Here the artist has added written notes that record items of interest about the particular outdoor view.*

In what size should I work outdoors?

Factors that influence size when working outdoors are the complexity of the subject and the changing light. If you are sketching studies to finish in the studio, you can work just large enough to record the information you will need. Another factor that influences size is the time available. Large drawings are time-consuming, even in rapid media like washes or charcoal, and wide areas take time to cover; if your time is limited, a smaller scale may be the most practical.

Right: David Ferry, charcoal and charcoal pencil *These media are not best suited to small sketchbook drawings, but can be used to advantage on larger-scale location drawings; this study of buildings is A1 size.*

Have you got any tips for using my sketchbook studies back in the studio?

Sketchbook studies should be used to conceptualize future studio drawings, and you can also use them to plan a palette and then experiment in mixing and blending the colors before you commit them to the actual drawing. Keep a sketchbook diary of colors you actually used to re-create that mix in other artwork. Apply the same technique more widely and use your sketchbook to take notes in the field for later use; it is amazing how much can be forgotten or misinterpreted once back in the studio. However, the way in which you use your sketchbook as a reference tool in the studio is a very personal thing that differs from artist to artist.

As an exercise, try making a drawing from a series of sketches and notes done in one location. When you start to draw your finished work in the studio from your sketches, you will soon discover the sort of information that you should have recorded.

What are some tips for sketching on vacation?

The prospect of having time off, whether a day or two of leisure or a lengthy trip to an exotic location, has a dual purpose for the dedicated sketcher. Here are new subjects and interests, a sense of color and energy, unfamiliar places, and different ways people behave when they are relaxing and enjoying life without the need to keep up appearances or watch the clock. And here is the time and opportunity that the artist needs to be able to sketch freely and with a fresh eye, as both a participant in and an observer of the scene.

The formal and pictorial interests – structures, composition, color, detail – are fundamentally similar whatever the subject or location. Alternatively, it may be less the objective image of the scene or view that interests you and more the mood or atmosphere that sums up the flavor of life and leisure in an unfamiliar place. And there are individual themes that may take your attention – the beach, for example, might be regarded as a colorful and informal life class for study of the human figure.

Packing for your vacation

Think about the types of materials you will need to pack with your vacation luggage. If you are going somewhere particularly exotic, you will want the capability of sketching in color. Take colored pencils or pastels, together with monochrome media. Consider how big of a sketchbook you might want to use and can conveniently pack and travel with. Keep materials and equipment to the minimum, but try not to restrict your technical options too much.

Viv Foster, felt-tip and marker *This series of images sketched in felt-tip and marker pens is designed to describe the idea rather than the reality of vacations, taking in different aspects of the events and locations that might be encountered on a vacation trip.*

Can I complete a large, complex drawing on location?

Yes, it is perfectly possible to do this using most drawing media; try this simple exercise to explore the possibilities. You will need an unbroken period of at least two hours for this; if you stop and plan to continue later, you will probably discover after the break that things look so different, you will not know where to begin again. First make two or three sketchbook studies, then look at them carefully, and decide which one will be best to develop as a larger drawing.

This can be any size up to A2; the aim is to make it as large as you can. It should be in both line and tone, and you may wish to use color. Make as complete a drawing as you can on location; do not try to do something quickly and finish it when you get home, as this will not work.

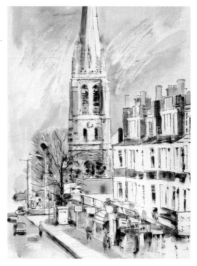

Above and below: Philip Wildman, pencil *These three rapid pencil sketches have been made from different viewpoints to explore the compositional possibilities of the subject. The one above right was chosen as the basis of the larger drawing.*

Above: Philip Wildman, pen and wash *This is the finished drawing worked up from the three sketches. Here the artist has turned to a different medium from the original graphite, pen and wash, which he uses frequently and finds ideal for urban subjects.*

CHAPTER

6

LANDSCAPES AND TOWNSCAPES

Are landscapes better left to experienced artists?

No, not at all. For emerging artists landscape subjects have obvious benefits: The organic shapes in nature are less intimidating than drawing other representational objects, and if your drawing of a tree is bent, it is not as noticeable as a bent nose in a portrait.

As you explore the possibilities, you will find the landscape is a subject with many advantages. It stays still, except when blown by winds or hushed by storms. It can take on many different and interesting moods. Light moves across it, for instance, to bring shifting relationships of tone and color.

Skies, which are sometimes thought to be the single most important feature in a landscape drawing or painting, also vary widely. They can range from leaden gray, dark and threatening, against which features stand out as bright and highly contrasted, through the huge, cloud-filled variety to a bright, clear backdrop to rich foreground detail.

ARTIST'S TIP

The various colors, textures, values, and movement in a landscape are an excellent way to challenge your drawing skills.

What is the process of composing a basic landscape drawing?

What you should aim for in your landscape compositions are inventive and surprising angles, views, and atmosphere. A good way to start drawing a landscape is to view the landscape through a viewfinder (see page 138); this helps to choose the best pictorial composition.

Start by drawing a rectangle on your paper; this is to represent the picture plane as seen through the viewing frame. Decide where you are going to start, and with a 4B pencil make a

continuous line drawing of the scene in front of you that you have selected through your viewfinder, going around the main outline of all the features. Once all the large features are drawn, add lines designating all the large areas that are in shadow and shade. If you intend to use this as a thumbnail or as a basis for a full painting, you will probably have sufficient information for it at this stage. If, however, you intend to take the drawing to the state of a

finished work now, start working greater detail into areas in the middle ground, so that the drawing begins to develop a sense of three-dimensional space.

Start to outline the areas that are in deeper shadow within the already drawn area of shadow. Shade both these areas again. Now concentrate in greater detail on those areas of the composition that you have decided to make the focal point. If the focal point

of your composition is in the middle distance, again, do not over-embellish. Successful drawings may depend far more on what is suggested to be there than what actually is.

ARTIST'S TIP

Always leave room in your composition for the imagination of the viewer. Select elements of the composition that are visually most useful to you.

Left and above: *You can see that by altering the position of the picture plane, the composition of this drawing is altered.*

How can I practice drawing a landscape scene?

The best way to do this is to start with a familiar subject, such as your garden or a local park. Take time over a series of days to look at it in the most concentrated way possible, even

before making a single mark on your support. This kind of concentrated consideration before drawing will often surprise you, and your eventual drawings can only benefit as a result.

How can I capture the quality of light during different seasons?

Surface effects of color and tone are influenced by the direction, strength, and color quality of the light falling on them (see page 112). The quality of natural light changes according to the time of day and season, so if you can capture a particular quality of light, you will add an extra dimension to the sense of location. Quality of light is described by the overall color key, the relationships of the areas of light and shade, and individual notes of color provided by highlights and color accents.

This is an area where acute but rapid observation is needed, where you must train your memory as well as your eyes to take in the color cues and learn to trust your responses to the passing moment. Make rapid studies of your subject. To make them, you can for the time being give secondary consideration to form, which will not change and can be studied at more leisure. You need only to sketch out a view roughly to make a "map" on which the color values can be located.

However you arrange your opportunities to study the subject, there are particular elements to look out for that provide the necessary clues to the qualities you want to capture. When you are looking at a subject with large blocks or areas of local color, try to identify the precise color values in relation to each other and the source of light. For example, in landscape look at the range of greens, and their clarity and color bias toward blue or yellow. It is the tonal scale of a drawing that makes or breaks the sense of illumination, so observe this not only in terms of color intensity and light or dark tonal values but also with close attention to edge qualities and gradations of light and shade.

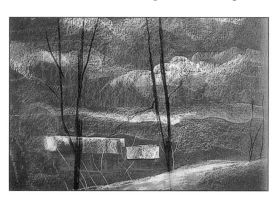

Left: *Winter landscape*, John Elliot, pastel *In this pastel drawing the dark-colored paper gives a dense, threatening mood to a wintry landscape.*

How do shadows affect a landscape?

Shadows are critical to identifying form and also play a vital role in creating a strong lighting effect in a landscape. When looking to interpret a landscape, the artist needs to consider the following related questions: Does the light emphasize contours, creating hard-edged shapes, or soften and merge the forms? Do the shadows that model form show abrupt transitions between light and dark or a wide range of middle tones? Does the light etch the textures more strongly, or underplay surface difference?

Cast shadows are crucial in creating a strong lighting effect in a landscape; draw them with either heavy tonal density and solid outlines or a more fluid, amorphous quality, depending on their appearance. Pay particular attention to their direction in relationship to the light source and how far they reach away from it.

At the same time, the color qualities in the shadows help to give surface activity. Look for dark tints of blue, green, purple, or red in shadows, as these provide color cues that can be played off the lighter tones. Note also which shadows are neutral in color, as these will intensify the pure hues and pale tones. Also look for color accents of reflected colors and highlights.

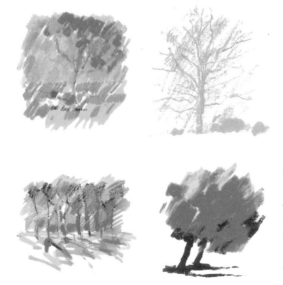

Left: *Shadow patterns are described in different ways in the top two drawings, in one by distinct color changes, in the other by tonal scale. Cast shadows on the ground form linear patterns in the bottom two drawings, and both have been treated with a tonal range of emphatic contrast.*

How can I capture exterior light effectively?

When you seek to capture an effect of exterior natural light, it is not usually possible to obtain all the information you need in a single period of concentrated drawing. Rather, you must train your eye to be alert to the cues of color, tonal contrast, and patterns of light and shade that are typical of a particular time and place. For example, these factors will differ in morning light from that of high noon, later afternoon, and dusk. If you make a number of rapid studies of a whole view or individual details, you build a body of reference work that subsequently can be used as the basis for constructing more complex and detailed drawings.

> **ARTIST'S TIP**
>
> You should always bear in mind how the medium and technique that you select can most aptly convey the qualities of your subject.

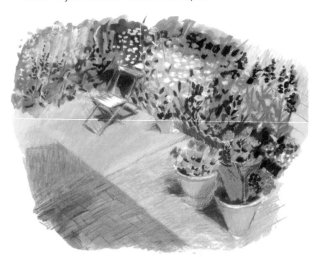

Left: *This study shows a garden view in afternoon light, with rich, strong colors under full sun and hard-edged dark shadows cast from standing objects.*

Right: *In these two smaller drawings of the potted plants, the artist investigates the different qualities of cool morning light, with pale tints and cool shadows, and the more intense light of evening in which the colors are all tinged with red and gold.*

How can I depict mood and character in landscapes?

Landscapes change their mood and character from minute to minute. The season of the year, the time of day, and the weather all create a mood and a particular atmosphere that can provoke a powerful response in you. As well as re-creating the mood of the weather in your drawings, your main problem is going to be drawing movement. Clouds move quickly, light changes constantly, nothing in nature stays still.

However, drawing is the quickest means of responding to a visual sensation; a few lines can evoke a particular person or place, and the way these lines are drawn – their softness, sharpness, or the speed of their execution – can describe the artist's response to the subject. Tone is particularly useful in creating a particular mood or atmosphere. Sharp contrasts of black and white will, for example, help to evoke the brilliant sunlight of a summer's day. A drawing that is almost entirely black will have a feeling of doom and despondency.

> **ARTIST'S TIP**
>
> When working outdoors, make full use of color accents, such as brilliantly colored flowers among trees and grasses, and atmospheric light effects, even when they are fleetingly seen, to enhance mood and character.

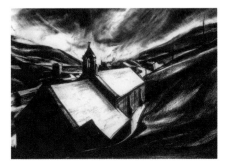

Above: Brian Yale, pastel *In this deceptively simple-looking pastel drawing the artist has distilled the essential visual elements, re-creating the dramatic moment when the sun disappears into a cloud.*

Above: *St. Gabriels,* **David Carpanini, charcoal** *Here too is a powerful sense of atmosphere. The swirling clouds are echoed by the wavelike shapes of the fields and hills, with the small church the stable center of a landscape in flux.*

What is the process of capturing a changing landscape?

Pastel is an excellent medium for capturing the movement and energy of a changing landscape, as it is possible to use it to work with linear marks and masses as well as color. Working quickly, you can build up a range of gestural marks that suggest an ever-changing scene, as shown below.

Soft and hard pastel

1 Make a quick start, by loosely applying the main blocks of color. A sense of depth and directional forces within the drawing has become apparent already through the variety and sizes of marks made.

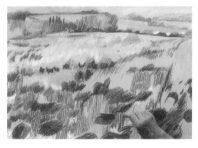

2 Keep these first marks fresh while establishing the main color areas, and pay close attention to the tonal ranges you introduce. Simple, directional lines add energy and vitality.

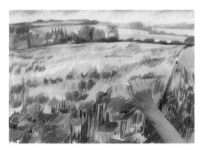

3 Start to introduce details, still working in a loose and gestural way, and continue the process of emphasizing and contrasting the movement within the image.

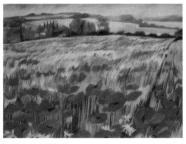

4 Using your fingers, rub in the soft pastel to create more solid blocks of color. Final details are added with hard pastels. Reinforce areas where colors meet, to give definition.

How can I reproduce the textures and patterns of a landscape?

Because soft pastels are light and portable with a wide range of colors, they are a good medium with which to capture the textures of a landscape. The textures and patterns to be found in nature quite often need to be drawn out. However, as shown in this demonstration, you can use colors creatively, to produce an imaginative drawing rather than being limited to what you see.

Soft pastel

1 Start by planning the composition using a white pastel, making sure that all the main features you want to include fit within the dimensions of the paper.

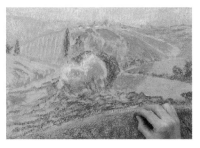

2 Now introduce color, bringing together cool and warm shades that work together well. The textures of each element grow from a variety of small marks of different colors.

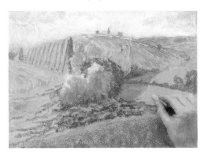

3 Keep using light touches of colors to create the textures and patterns of the fields. Other quieter areas in the right middle ground are left to create a balance.

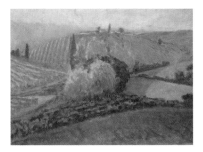

4 Make details in the background precise by using pastels sharpened by a knife. Textures and patterns can be created by the range of marks you make, as well as changes in color.

How are landscape and townscape drawings related?

All the theories and pictorial approaches apply equally well to landscapes and townscapes. It is possible to make a very successful drawing of a landscape where no buildings at all are present, but the inclusion of buildings adds a further pictorial element that can be used to great effect. The geometrical precision of buildings, when used in contrast to natural landscape, can create a visual tension, and the same is equally true in reverse of a row of trees lining a central city street, which contrast to the geometrical hardness of the buildings.

How should I approach drawing townscapes?

For the artist who wishes to seriously tackle the subject of the townscape it is essential to approach the subject with an open eye and an open mind. It is not necessary to live in a great metropolis or city renowned for its architectural beauty. Any town or small industrial center can provide a lifetime of subject matter for the sensitive observer, and even the uniformity of many suburban streets can present a pictorial rhythm unique to the local environment. A row of identical suburban villas might not seem a likely subject, but if the artist concentrates on those details that the owners have added to their homes to give individuality to what were originally identical structures, an interesting drawing can be made of what might otherwise have been dismissed as a mundane and commonplace subject.

Above: *Townscapes*, Ian Simpson, line and wash *Two complex townscapes, which combine to form a continuous image, depend on a strong framework of ink and pencil line drawing. Within this structure, color washes are applied as representational color describing roofs, walls, chimneys, and the street below, enhancing the sense of place and time. Loose brushwork adds to the detail, suggesting a range of surface qualities.*

Besides buildings, what other subjects does a city offer?

Our contemporary city environment presents many possibilities besides buildings. Brightly colored vehicles stacked in rows in a drab concrete multilevel parking garage could quite easily be turned into an interesting pictorial study. The grotesque silhouette of an industrial plant, which obeys none of the proportions necessary in an inhabited building, can give the artist a whole range of visual possibilities: Such structures obey their own strong logic governed by the industrial processes they are designed to serve.

Another area of the city that is well worth investigation is the forest of billboards and neon displays that give any shopping precinct its great visual variety of shapes and colors. The city at night can be particularly visually exciting, its multitude of light sources casting shadows in all directions. A good starting point for a work done at night might be a gas station, with its constant movement and brightly lit forecourt, representing an oasis of light and color in an otherwise dimly lit suburban street.

ARTIST'S TIP

Brickwork, ironwork, and interesting structural details of doors, windows, balconies, and moldings are all elements that can be selectively introduced to enliven the basic forms of a cityscape.

Left: *Urban scene*, Stan Smith, oil pastel
Broad, generalized color areas are contained by linear drawing to evoke the atmosphere of late evening in this drawing. Dark tones created by a series of vigorously overlaid colors are occasionally relieved by small areas of bright color that represent the clarity of a lighted window shining through the twilight. The linear form of a giant crane on the skyline behind the buildings is treated with finer marks.

Should I include peripheral man-made objects in my drawing?

Try not to ignore those objects that you might feel are an intrusion of modern life on the town, such as traffic signals and signs and refuse containers. You might not like them, but they are indispensable pictorially. Many beginners omit these things from their drawings in an attempt to portray a street scene of predominantly older buildings, as though the drawing was done when the buildings were first erected, say during the nineteenth century. Works carried out in this frame of mind inevitably look unconvincing because many other pictorial elements that would have been present in the nineteenth century are not there – particularly horses and carts, and figures in period costume.

What are the subject options if I have no access to a town or city?

The first attempt for those who do not have easy access to a town could well be to portray a local church. Farmhouses, outbuildings, and barns can give you the practice you need, and with imagination this type of subject has many possibilities. But there are other ways in which to tackle such drawings; street scenes of villages also have considerable potential. Corner shops, squares, and marketplaces, and statues and war memorials all hold great pictorial value.

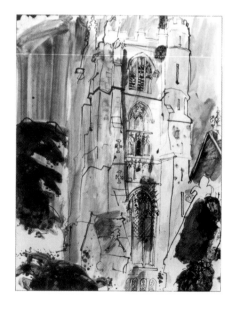

Right: *View of church*, **Stan Smith, pen and ink, pastel, oil pastel and pencil** *In this drawing, the artist has created the sense of a bold building that has stood against the elements for centuries.*

What is the real function of a sketchbook when drawing townscapes?

A sketchbook is the place to record visual information that can be useful in the studio. Because of the difficulty of trying to set up an easel and stool in a busy shopping area, the usefulness of a sketchbook comes into its own when drawing buildings. This is the place to practice your perspective, determine how much of the townscape you want to include, develop a focal point, add figures, adjust tonal and color values, and record the light and shadows.

Do I need to master anatomical drawing to include figures in my townscapes?

For those artists with a little more confidence, the inclusion of people in a townscape can add another dimension. There is no need to be a master of anatomical drawing to include figures; you can actually express a range of human personality with the minimum of detail. Once again it is sharp observation of human character that is all-important to give a beginner the confidence to include figures.

Right: *Montague Road*, **Tony Coombs, charcoal** *Notice how the artist has loosely drawn the figures in this street scene. Although he avoided any details, they still read well and are believable.*

FIGURES AND ANIMALS

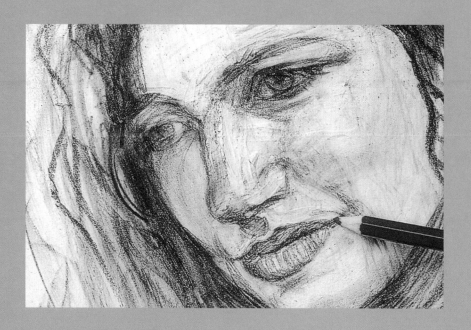

What are the proportions of the figure?

There is no standard human being: Everyone is different. But since the similarities are greater than the differences, it is useful to remember some general points about the figure, and in particular about its proportions.

The head, measured from the crown to the chin, is used as the "yardstick" for measuring the height of a standing figure. The widely accepted proportion is that the length of the body of both the adult male and female comprises seven and a half heads.

The other key proportion is that of legs to torso. The groin is the approximate halfway point in the height of a standing figure, not the waist, as people sometimes assume. There are, of course, differences between male and female, and although these basic proportions are similar, the male is generally much broader across the shoulders and narrower at the hips than the female.

Below left: *Few of the people you draw are likely to conform absolutely to a norm, but you will find the rule that the body is seven and a half heads high useful as a check.*

Above right: *As a general rule, the man's shoulders are broader and squarer than the woman's, and the hips are narrower in relation to the waist. The proportion of the head to body is more or less the same.*

How should I structure the figure?

To base life drawing exclusively on a knowledge of human anatomy is both very difficult and inadvisable, so an alternative, simpler way of structuring the forms has been devised known as the geometric approach.

Most artists suggest the torso in terms of an elongated cube connected at the

lower part to the legs and attached above to the cylinder of the neck. On top of the neck is the head form with the cranium on top. The arms are suggested as cylinders, hinged at the elbows, as are the legs, similarly hinged at the knees. Feet are attached at right angles and are considered as platforms;

hands flatten, spatula fashion, the narrowing tube of the lower arm. Toes and fingers are cylindrical, radiating out from a point set at the center of, respectively, the front of the ankle joint and the wrist.

This is a useful, very basic guide to figure construction, but it must be made more refined and sophisticated. This is because the interrelationship between parts is absolutely critical, the angles at which the separate elements join up being as important as the forms themselves. Practice drawing the figure as a collection of these simplified volumes in order to help you acquire a firm understanding of this structure. You need not literally represent the figure in terms of cubes, spheres, and cones, but bear them in mind constantly as you draw as a basis for interpreting the volumes of the figure.

The geometric approach

The two diagrams shown here illustrate the basic geometric structure of the figure, using the cylinder and sphere together with modifications of each. Diagram B is simply an elaboration of diagram A.

A

Sphere

Modified cylinder

Bucket

Cylinder

Note relationship of cylinders

Cylinder

Cylindrical form overlaid on basic leg shapes

B

Sphere

Cylinders

Neck cylinder

Semi-sphere

Cylinder

Sphere

From simple cylinder, note how subtle movement makes leg forms develop

Are there any tips for checking proportions?

The drawings that result from a rather casual look at the figure often have two major mistakes: overlarge heads, and legs that are too short. It is always wise to check your drawing to see that the head and legs are about right according to "average" proportion (see page 160). You will obviously find that some people have shorter legs than average, or smaller heads, and you should recognize and record these characteristics.

It is not too difficult to check proportion when you are drawing a standing figure, but it is harder when the subject is seated. In this case,

particularly if the view is from the front, you must take account of foreshortening (see page 132) when you check the proportions, so to judge whether the proportions would be reasonable, you have to imagine the seated figure in your drawing actually standing.

ARTIST'S TIP

The most common error in portrait drawings is making the features much too large. Also, if the head is seen in profile or from a three-quarter view, its depth is often underestimated.

Right: *The rules of proportions are not much use when it comes to foreshortening – here you must trust your eyes. Compare the relative lengths of the thighs in the two photographs.*

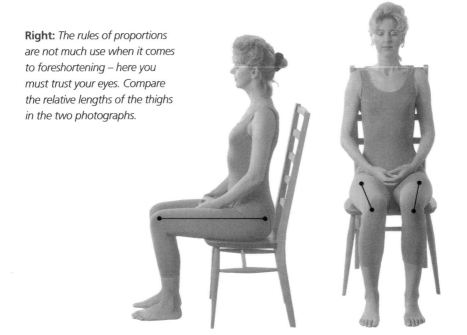

What are the proportions of the human head?

Not surprisingly, drawing the head presents problems similar to those encountered when drawing the figure. The proportions tend to be ignored as you try to draw those features that you feel will make the person identifiable. The surprising thing about the head is that the features occupy a much smaller part of it than most people first think.

If you have a front view of the head and measure the position of the eyes, you will find that they are on a line approximately halfway between the crown and the chin. A line drawn through the bottom of the nose is halfway between the eyes and the chin, with the mouth approximately halfway between nose and chin. The depth of the head is also deceptive. Seen in profile, the distance from back to front is the same as from the crown to the chin.

Left and above:
When the head is angled upward, downward, or to one side, it is seen in perspective, and the features occupy less space than in a straight-on view.

Is there a geometric approach to analyzing the human head?

The physical structure of the face is complex, but with intelligent observation and the use of the geometric approach shown, accurate and sensitive drawings can be achieved. This, however, is not the only aspect to consider, for in addition to building a head in pencil or pen and ink, there is another dimension to understanding the human face. Concepts such as personality and communication through eye contact cannot be ignored and must be incorporated.

Below and right: *Side and back views of the head show how the basic shapes can be expressed in terms of geometric forms. It is important to note the angles at which these shapes interrelate with each other.*

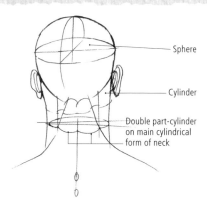

Sphere

Cylinder

Double part-cylinder on main cylindrical form of neck

Sphere —
Sphere—
Sphere—

Note angle of neck as it attaches to the head

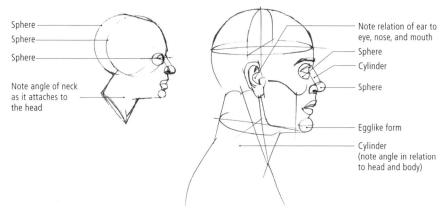

Note relation of ear to eye, nose, and mouth

Sphere
Cylinder

Sphere

Egglike form

Cylinder (note angle in relation to head and body)

Left and right: *Front views of the head, showing an increasingly complex breakdown into geometric forms. In the diagram top left the mass of the head is shown simply as a sphere with an interlocking modified cylinder. Again, note the angles at which the forms interrelate and the thickness of the neck.*

Cut under brow

Lids overlaid on spherical forms

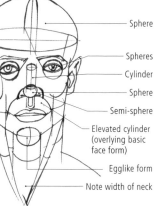

Sphere

Spheres
Cylinder

Sphere

Semi-sphere

Elevated cylinder (overlying basic face form)

Egglike form

Note width of neck

How do I approach drawing a portrait?

Some artists worry when confronted with drawing the human figure. However, no matter whether you are drawing a landscape, a building, a figure, or a portrait, the basic problems of seeing, selecting, and translating remain the same.

The human figure is based on simple geometric shapes: A three-quarter view of a head is not very different from a similar view of a box, with the roundness of cheeks and chin. The perspective of a head is similar to the perspective of a box: Lines drawn through the eyes and the mouth, for example, would when extended converge at a vanishing point on your eye level. The forms of the head, however, are more subtle than those of boxes and cylinders. Perhaps the main difference is that the figure demands a standard of accuracy that is generally far greater than that required for drawing a tree or plant.

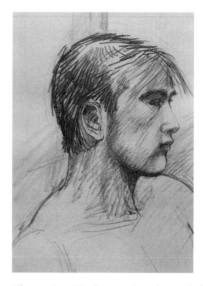

Above: Ray Mutimer, colored pencil *The modeling of forms is accurate in this profile-view drawing, and the glimpse of the far eyebrow and eyelash, and the shoulder seen overlapped by the chin, also help to create depth and volume.*

What is the importance of lighting in portraiture?

Generally, the forms of the face and head can be explained by selectively describing the light falling on them, and therefore the way a portrait is illuminated is very important. If you are working from natural light, you must plan your sessions to be at roughly the same time of day. In

the history of portraiture there have been different preferences for the way the sitter should be lit.

Some artists, of whom Rembrandt (1606–1669) was one, liked strong contrasts of light and dark. Others worked in what became known as the

"Italian manner," without extremes of tone. If you light your model from the front, you will be able to try the rather flat lighting that characterizes the Italian manner. Whether you use natural or artificial light, experiment with lighting your model from different angles and directions.

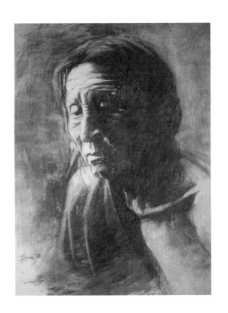

Right: *In tough times*, Leonard Leone, conté crayon *The shadowed side of the figure has been beautifully drawn in a single tone, and the light side of the head is separated from the soft background with a sensitive line that at some points completely disappears.*

What is the process for drawing a portrait?

The model is your most important asset, so first make sure he or she is comfortable. Position yourself so that you have a three-quarter view, and choose your medium.

Before you begin to consider the details of features, make certain that the main proportions of the head are correct. Check the overall shape of the head. Is it long and narrow? Is it rather square? Do not worry about getting a likeness; your first priority is to make the drawing look three-dimensional, with the features fitting convincingly.

As you draw, think about what you see. For example, the eyes are in hollows and the lips are two rounded surfaces, one probably turned up toward the light and the other in shadow. The nose is a form projecting from the front of the face, and you must draw it indicating planes at either side and underneath.

Drawing someone's portrait may seem daunting, as you may be anxious about how they will react to seeing it. Do not be too concerned with drawing a likeness, though; give consideration to form, color, and tone. If you look hard for the underlying structure of the head and face, as well as important characteristics of the sitter, you will probably end up with a good likeness.

Conté crayon

2 Having added light areas, now draw with a colored pencil to build up the darks and define detail. Use the paper itself as a mid-tone.

1 Use conté crayon on toned paper to establish the shape of the head, position of the features, and the main areas of shading, which will make the head appear solid and three-dimensional.

3 Apply further touches of lightly colored pencil to introduce hints of color, and to build up the facial forms.

4 The features are well described, but the shading and touches of color have been applied in a free and spontaneous way so that the drawing remains full of life.

What is the process for drawing a portrait in full color?

One of the most important aspects of drawing a portrait in color is achieving a realistic skin tone. Knowing that your sitter is alive and warm may predispose you to use warm flesh colors. In fact, the shades observed are subject to lighting conditions that may be cold or hot, and the skin color of the sitter is in turn dependent on age and race.

Remember that the sitter's environment and clothing, and the source of light – natural or interior, along with its temperature – will affect skin tones. Most beginners play it safe by producing uninspired beige portrait drawings, particularly when they are working on a white surface. To avoid this, experiment with different colored papers.

Oil pastel

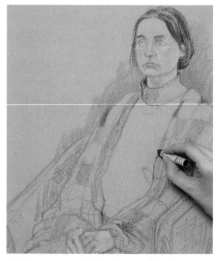

1 Select an attractive, neutral-colored paper, and draw the pale values in addition to the dark tones to help you gauge proportions and dimensions. Oil pastels soon saturate the surface, so keep applications to a minimum until you have confirmed placing, perspective, and negative shapes.

2 Take account of the background and garment colors as well as the skin tones. Color tones and temperatures can be assessed only in relation to each other, so establish new values against existing colors. Make regular checks, and if a color seems unmatched, adapt your mixture before going further.

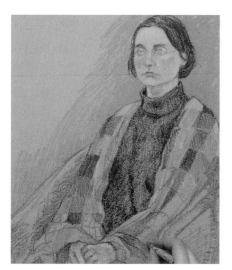

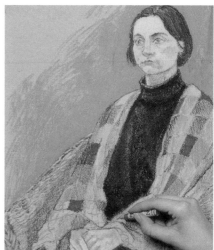

3 Apply colors lighter than you intend them to be finally, to allow for corrections. Include any patterns on clothing, as these are invaluable for helping to describe the form of the wearer. Keep up progress on the portrait head, adding color to skin tones and beginning to define the features.

4 Bring the main elements up to full tonal strength by applying a thicker color coating. Unify minor elements that are not yet up to full strength of tone and hue with the color scheme. You can transpose color values to brighter or quieter shades, or darker or lighter tones, as long as you do so throughout.

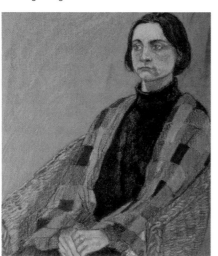

5 The eye will be drawn to any highly worked element, so concentrate the most intensive color details in features, then the hands, and then the clothing. The background must be rendered plausibly, but keep the colors marginally less intense.

How do I start to draw a nude model?

There is no doubt that drawing a nude is an exciting challenge. Do not be overawed; draw it like the other subjects you have drawn by selecting what you think is important and translating from what you see. To get started with drawing nudes, complete two poses, one lasting about fifteen minutes and the other about one to two hours, not including breaks, as described below.

Short pose

For the first pose draw quickly and spontaneously, going for the essential features of the pose. Get your model to stand for this if possible. He or she can rest against a table or chair so that they do not have the difficult and tiring task of standing unsupported. Try to include everything you can in the time available,

but if you see that your drawing is basically incorrect, do not add detail. Getting the balance and proportions right matters much more than whether the features or fingers have been drawn.

Long pose

For the long pose, your model should be seated or reclining. Begin in the same way as you did before, working quickly so that your drawing retains the liveliness of the earlier drawing. You can work in line, or line and tone. Do not be tempted to begin with small details just because you have more time. Every quarter of an hour or so, leave your drawing for a few minutes and look at the pose from different places in the room. This will help you understand the way the figure is positioned.

Right: Kay Gallwey, charcoal *The fifteen-minute drawing (near right) is in charcoal and white pastel, and for the longer pose the artist has used a small range of pastel colors.*

How far should I sit from the model?

The distance from which you draw the figure is very important. Most people draw objects the actual size they see them, and so if a figure is to be drawn reasonably large on an A2 size sheet of paper, it is no use drawing it from a distance. There is, however, a danger in being too close. Unless you draw a figure from 6-8 yards (6-8m) away, you may produce a very distorted drawing because you will not be able to see the complete figure at one glance.

Can I keep working without the model?

Absolutely; when the model takes a break, it does not mean that you have to stop drawing. The break gives you an opportunity to assess your drawing and decide which things need special attention when your model returns to pose. It is also the moment to draw the chair and parts of the background that are obscured when the model is posing. This will enable you to see whether everything is fitting together satisfactorily in your drawing.

What is a plumbline?

Drawing a standing figure is always easier if you have a vertical line to use as a reference. If there is not one in the background, you may find that a plumbline is a helpful alternative. For hundreds of years artists have drawn figures with the aid of a plumbline, which is simply a weight on the end of a length of cord. If you are a carpentry enthusiast, you may already have a plumbline, but if not, one can be made in seconds. All you need is a piece of thin cord about 1 yard (1m) long and something small and comparatively heavy with a convenient hole in it through which to thread the cord.

Above: *By holding a plumbline, which provides a known vertical, the various angles of any pose can be more readily appreciated.*

What do I need to know about drawing clothed figures?

When drawing clothed figures, you will have to cope with an additional difficulty. Although garments simplify the forms of the figure, they can also disguise them, so it is necessary to consider the body underneath if the drawing is to look convincing. This does not mean that you have to be able to imagine the concealed figure in great anatomical detail, but it is important to visualize the way the neck, appearing from a shirt, joins the shoulders, or the legs, visible below a skirt, join the hips.

In the case of a standing figure, it is vital to be able to analyze the characteristics of a particular pose. The best way to understand what this means is to get someone to stand for a few seconds first in one position and then in another, and try to see what effect the change of position has on the body. Notice, for example, that if the weight is mostly on one leg, the hip above this leg is raised and the opposite hip drops.

If you then look at the shoulders, you will find they compensate for the tilt of the hips by sloping in the opposite direction. In order to avoid falling over, an unsupported figure has to maintain its balance around a center of gravity. You will find that a figure standing with its weight on one leg has its head on a vertical line directly above this leg. Check this for yourself, and check also how the center of gravity changes with the pose.

Left: Elizabeth Moore, pastel
These drawings have each been made in no more than three minutes, drawn rapidly in line with pastel. Pastel is an excellent medium for quick studies, as you can block in areas of color and tone very speedily.

What are some tips for foreshortening a seated figure?

An understanding of perspective is essential to avoid some of the pitfalls of figure drawing. Try to work at a distance from your model that enables you to view the whole of the figure at one glance, to avoid the optical distortions that arise if you are too close to the head or feet. While you are still a beginner, it is easier to make a properly proportioned figure if the feet, head, hips, breasts, hands, and other parts of the body are all at the same distance from your viewpoint.

By the principles of foreshortening (see page 132), objects closer to the eye appear greater in size than those at a distance. You can incorporate this distortion into a drawing creatively, although in the case of extreme foreshortening, when the figure is seen from very close either to the head or the feet, there are many problems of perspective. It is necessary to measure carefully by holding the pencil at arm's length and squinting.

Similarly, when someone is seated and looking down, their features are foreshortened and you see more than usual of the top of their head. When you have a front or three-quarter view of the head in an upright position, the nose is slightly foreshortened, but with the head tilted down the nose appears to be longer. When the head is held upright, the features occupy half of it, but when the head is looking down, they may occupy a third or less.

Try drawing a seated figure. Have your model sitting comfortably on a chair looking down at his or her knees, with hands resting on thighs or holding a book. Start by spending fifteen minutes or so just getting the proportions of the figure and the characteristics of the pose right. Try to draw with freedom and vitality.

Reference photograph

Charcoal

1 Start by drawing the distinctive shape of the hair framing the head and below it the triangle made by the arms and clasped hands.

2 Identify the foreshortened features of the head, drawing the full length of the nose and reducing the lower part of the face to almost to nothing.

3 Use strong vertical lines to shade the sweater; this will add to the downward thrust of the pose.

4 The strong, simple shapes, stark tonal contrasts, downcast head, and tightly clasped hands give this work a powerful emotional quality.

ARTIST'S TIP

When drawing a foreshortened figure, think about how the width of the figure, or an individual limb, compares with its length, and remember that often the best way to get a difficult shape right is to draw the negative shapes around it.

What can I do if I do not have a model?

When you cannot find a model, find a mirror. The practice of drawing self-portraits goes back before ancient Egyptians. Many famous artists, including Rembrandt (1606–1669) – he completed a self-portrait at least sixty times – chose to document their own image various times. Self-portraits are good therapy and can result in a deeper awareness and discovery of self – not only of the physical but also the psyche. The alternative to self-portraiture is joining a life class and sharing a model with a group of other artists. Although you may not get the exact pose you want, by carefully choosing your position you will be able to set yourself some interesting problems to explore.

Above: *Although the artist used herself as a model, her goal was not to depict a traditional self-portrait but instead to make the work more painterly and artistic within a context.*

What are some guidelines for drawing a self-portrait?

Choose a drawing medium that allows you to build up good solid masses of form. Position yourself in relation to a mirror so that you have a three-quarter view of your head, not a full-front view, and sit so that you are comfortable and can move your eyes from your drawing to the mirror without moving your head. This is important: It will help you draw accurately and save you having to reposition your head each time you turn back to the mirror after drawing. If possible, position the mirror so that light falls on your head from one direction.

Drawing a self-portrait will reveal things about your appearance you may not have been aware of before. You may be surprised at how asymmetrical your features are. Slight differences between the shapes of your eyes or a twist in your nose are examples of things to look for and record.

How do I draw a hand?

Although each finger has a certain expressiveness and fingers are commonly thought of individually – for example, the index finger, thumb, and so on – it is impossible to draw the hand one finger at a time, and it is only when the hand is seen as an overall shape, including the first section of the lower arm, that it can be successfully tackled.

The hand, like the head, is a much larger object than most beginners think. Place the bottom of the palm of your hand on your chin. You do not have to spread your fingers very widely to cover the majority of your face. But look at any untutored drawing and you will find that the hand is drawn as five very small fingers coming out of the end of the arm. The hand really begins some distance back from the wrist joint.

It is well worth a beginner's time to study the hand. The easiest hand to study is, of course, your own, and with the aid of a mirror you can draw it from various angles. Start by making a line drawing of the whole hand and then drawing into this shape the individual fingers and spaces in between them. Keep drawing the hand in a variety of positions, concentrating on the whole shape, and you will soon start to see a marked improvement.

Left: *Note that the fingers radiate from the wrist with the thumb in opposition. It is essential to observe and understand the range of movement of the thumb.*

Left: *When making initial sketches it is a good idea not to attempt to treat the fingers separately, but rather to draw their overall shape.*

Above: *In these pencil drawings the main form of the hand is contained by a precise linear contour, which has been completed by light shading.*

What should I bear in mind when drawing human hair?

There is such a range of hair textures and styles that it is near impossible to generalize about them, but there are some points to bear in mind when you are drawing hair. The most important is to ensure that you relate the hair to the head itself. This sounds obvious, but if your subject has an elaborate hairstyle, it is only too easy to become so involved in the intricacies of the curls and waves that you forget about the shape of the skull beneath and the way the hair relates to the face. Start by blocking in the main masses and then pay careful attention to the rhythms of the hair.

Look for the weight of the hair, as this is important in giving shape to the style, even in the case of short hair. Thick, heavy hair holds its shape better than thin, wispy hair, and the more shape it has, the easier it is to draw. Thin, frizzy, or flyaway hair is trickier because it does not always follow the shape of the head very precisely, and is in general more demanding in terms of technique. The final quality to look out for is the sheen of the hair. Dark, oily hair will have very pronounced highlights; thick, dry hair diffused ones, and thin, dry, or frizzy hair almost no recognizable highlight.

> **ARTIST'S TIP**
>
> To quickly create the highlights in hair, use a kneadable putty eraser to lift them out.

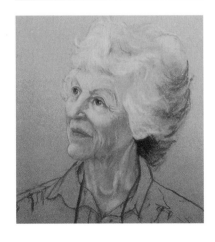

Above and right: *In both these examples, particular attention was given to the highlights and shadows of the hair. This is what gives it volume and makes it look three-dimensional. The sketch was done with graphite, and conté crayon was used in the colored drawing.*

What is the process for drawing hair?

Graphite pencil is a sympathetic medium for drawing hair because of its ability both to capture the softest nuance of tone and to describe fine lines and rhythms. For long hair try sharpening the pencil to a fine, tapering point so that there is plenty of exposed lead and draw using the side and the point of the lead. Use a soft 2B pencil to begin with, and hold the pencil in a way that will give you sweeping moves without feeling restricted. For short, curly hair, try a light scribbling motion, using a combination of different marks.

An effective method of drawing fine strands of hair is to use the technique of impressing thin lines into the paper with a sharp metal instrument (see page 22). The method requires a little planning ahead to ensure that the lines will be in the right relationship to the rest of the drawing, but the results can make it well worthwhile.

ARTIST'S TIP

To practice drawing hair, begin with a style that has clear shapes and forms. Ignore individual strands of hair and look instead for the main rhythms and movements; also look for the highlights and notice how they move across the main flow of the hair.

Soft pastel

1 Choose an off-white colored sheet of rough paper to act as a background and also a basic skin tone. Start by sketching in the outline of the subject's face and hair.

2 Now lay down the main shape and color of the hair with the side of a pastel stick, suggesting detail and movement with an ochre pastel used in a linear manner.

3 Introduce more dark brown in the shadowed areas of the hair near the face, and blend the outer edges of the hair to produce a softer effect.

Why is it important to use a background in a figure drawing?

Normally you should not draw the figure in isolation, as the background is a useful checkpoint for getting your directions and shapes correct. In addition, unless there is an indication of three-dimensional space behind the figure in your drawing, it will be almost impossible to make it look real and solid. Even a few lines describing perhaps the corner of a room or the shape of a window frame can be sufficient to create a feeling of depth.

Above: Kay Gallwey, conté *The figure in this conté drawing of the same pose is more closely integrated with its background. As before, the striped shirt has been used to explain the three-dimensional form of the figure, but it has also been drawn to contrast with the floral patterned rug on which the model is sitting.*

Above: Elizabeth Moore, pastel *In this drawing the artist has used the shapes around the figure to help her assess the slight foreshortening of the left arm, the lower torso, and the legs.*

What are the challenges of drawing animals?

Drawing animals presents several artistic problems unique to the subject matter. Firstly, unlike a human, few animals obey a command to remain still. A good place to start drawing animals is at the zoo, which has an abundance of animals in reasonably constrained areas. However, the constant movement of a tiger pacing an enclosure can still present tremendous difficulties. Speed and subtlety of observation are required to draw animals in the zoo environment.

Before any attempt is made to put pencil to paper, observe the animal for some time – how it moves, the size of its head, the proportion and weight of the limbs – and then with the animal in front of you create a drawing that is made as much from your visual memory and imagination as it is from direct representation. The drawing shown here was made from original sketches that were drawn at the zoo and also from memory.

Soft pastel

1 Sketch in the main form quickly with bold side strokes and a limited range of colors.

2 Use black pastel behind the head and trunk to help give them definition.

ARTIST'S TIP

When you first draw animals at the zoo, try to arrange it so that you are there during feeding time. This is the one time when, although the animals are no less active, they are more generally in one place.

3 Build up the rough concertina-like skin of the elephant's trunk with layers of short strokes.

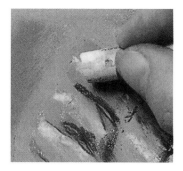

4 Create the smoother texture of the ear by blending the colors before introducing the small highlights.

5 Although the drawing is not complete, the textures of the subject have already been suggested convincingly.

What should I consider when drawing pet portraits?

Pet owners know that every pet has its own unique personality, expressions, and traits. Therefore when drawing a pet, you cannot just draw a generic animal, but must draw that particular one. Each of us perceives character differently. The better you know an animal, the more there will be to convey in the drawing. You will see signs of age, character, and temperament that are visible only after time.

Right: *Pokey***, Vera Curnow, colored pencil** *This colored pencil drawing captures the innocence and charm of a face only the owner could find beautiful.*

What are the pitfalls in drawing animals from photographs?

The biggest pitfall here is the distortion in proportions and perspective photographs can present. Another problem is that often the photograph will lack three-dimensionality and look flat, making it harder for the artist to capture these elements in the final piece.

Photographic reference may be of help, but should, if possible, be used in conjunction with visual notes made in the presence of the animal. If photographs are to be used, it is far better to use photographs that you have taken yourself, for they will not only act as a reminder of the animal's visual appearance, but will remind you of your own feelings toward it.

Above: *Puff*, Vera Curnow, colored pencil *Although this portrait of a cat was drawn from a photograph, the artist was careful to correct any distortions.*

How can I capture movement in drawings?

There are a variety of ways in which movement is depicted in drawing. Some can be seen most clearly in the graphic conventions used in cartoon strips. A rapidly moving figure is often shown followed by "movement lines" indicating that his or her body is not static. Our eyes readily follow strong linear directions, and this can give a line the attribute of movement. Movement in drawing is thus mainly created by use of line, and in part by the gestures made by the artist's hand as he or she works at speed.

The way the line is used is of the utmost importance. One kind of movement may be best described with fluid brush drawing, whereas another can be most effectively re-created with swirling pencil lines. Generally some realism has to be sacrificed to create an illusion of movement in drawing. Vitally, the energy that comes from sweeping strokes with your tool is much more important in generating a feeling of movement than the realistic description of detail.

Right: *Street walking,* **Carl Melegari, colored pencil** *Using mainly cool hues, the artist has organized the tone and color schemes to reinforce the impression of driving rain.*

How can I freeze action in a moving subject?

In making a drawing of a moving subject, you can also describe the object in different positions as it moves or "freeze" the action. If you do the latter, it is important to consider which precise point in the action you will portray.

Often it is more effective to show the instant before the most dramatic point of a particular movement rather than the height of the action itself. For example, if you were drawing a man striking a piece of metal on an anvil, the moment at which the hammer is raised to its highest point will give a much better idea of dramatic movement than the instant when the hammer hits the metal. Bear in mind also that the slightest movement, whether of a human figure or an animal, affects the whole body. Merely moving one foot in front of the other changes the complete position of the torso.

Left: John Skeaping, pastel *Time spent watching rapidly moving subjects, and acquiring visual memories, is always well spent. Tap into your research, combined with current observations, to produce dynamic studies as demonstrated by this pastel study.*

CHAPTER

8

STILL LIFE AND FLOWERS

What is a still life?

The words *still life* describe any painting or drawing of inanimate objects. Still life need not be the dull subject that it is often thought to be; the objects in a still life have often been selected very carefully. Historically still lifes, for example, included such things as hourglasses, skulls, flowers, and partly burned candles, intended to express the eventual triumph of death over life. In more modern times, artists often choose objects that have a more personal significance, such as books, possessions, or even the remains of a meal.

Above: Rosalind Cuthbert, pastel *A skull in a still life drawing usually denotes that it is of the vanitas type, a reminder of the fleeting quality of life.*

How do I find subjects for a still life?

Domestic subjects give you ready-made material for your drawings and the opportunity to work out the visual problems and possibilities at greater leisure. There is a very wide range of subject matter to be found in any furnished room. The general structure of the interior architecture is one: Its overall planes introduce the basics of perspective drawing; windows and doors can create areas of texture, unusual light effects, and glimpses of views through and beyond the room into adjacent spaces. The way furniture is grouped in the room can also provide subjects; the hard textures and surfaces of wood, plastic, and metal from which furniture is made contrast with the fluid forms and gentle contours of soft furnishings – curtains, cushions, and rugs. These often provide pleasing patterns that can enliven your drawings with their varied shapes and colors.

> **ARTIST'S TIP**
>
> Do as many drawings as you can to explore the possibilities of various subjects.

Should I look for attractive decorative items as subjects?

Attractive plants, flower arrangements, ornaments, and fruit bowls may be immediately recognizable as appealing subjects for still life, but do not neglect the more familiar and mundane possessions in your home: A jumble of randomly used kitchen implements lying on a worktop; garden tools standing by the back door; the brushes, paints, and crayons lying about in your studio. Because they are functional rather than decorative elements, it is easy to overlook their visual potential.

Above: *Home cooking*, **Valerie Wiffen, colored pencil** *The objects on your kitchen table can make a good subject, because they are associated with your daily life. The more bound up with them you are, the better you will be able to draw them. Make sure your objects are chosen for their varied visual qualities – glossy and rough, transparent and opaque, or round and angular.*

> **ARTIST'S TIP**
>
> Try drawing the kitchen counter – just as it is. Do not bother to clear away the random clutter of utensils and food packets; their shapes, patterns, and textures form a fascinating still life.

What tips are there for planning still lifes?

Once you have chosen your still life subject, two aspects need to be taken into consideration: the composition of your group and the way in which it is lit. The composition of your still life objects is one of the most important stages, and it is worth spending a considerable length of time trying out alternatives. Some examples are shown here.

Light sources are usually from above – either the sun or artificial light. Light from a single source such as a window is also common. It is important to remember that this light will not strike all the forms you are drawing directly; some of the light will pass them by, only to strike other planes in the vicinity and bounce.

Composing a still life

Above: *Classical triangular structure is recommended, but all the items are at the same level, and this level is parallel with the bottom of the picture, which does not work satisfactorily.*

Above: *In this rearrangement of similar elements, the angles create a more dynamic series of shapes. Some fruit is grouped together, and single fruits offer contrast.*

Above: *Here, rhythmic elements are used, and the hyacinth and curtain provide contrasting linear sweeps. The busy surface of the upper area contrasts with the lower surface.*

Lighting a still life

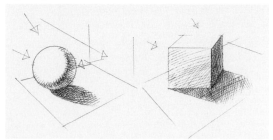

Above: *Most of the light from above and the left hits the sphere, but some travels on, bounces off a vertical plane, and returns to lighten the dark side.*

Above: *The lighting of the cube, coming from above and left, causes two differing tones on the planes, the one farthest from the light source being the darkest.*

Above: *Practicing on simple shapes will give you an opportunity to observe the effects of light.*

How do I handle shadows in a still life?

The play of light is one of the most important elements in a still life, and the shapes and colors of objects change constantly as the light changes. As an exercise, collect together four or five household objects and give them a coating of white emulsion paint so that they all appear to be made of plaster. The whiteness of the objects will help you see the effect light has in causing shadows. Set up your still life in a convenient corner, and direct light from one specific direction onto these now white shapes. Outline the pattern of the objects in front of you.

Then draw around the shadows. Notice that there are two distinct types of shadow. One is the shadow that is present on the side of objects away from the light source. This is called "actual" shadow and is more difficult to see, particularly on a cylindrical or round object, as the dark side gets progressively darker and the exact line where the grayness begins is sometimes difficult to see. Because the objects are painted white, however, this should be easier to recognize. A simple way for the beginner to draw the actual shadow is to decide where the darkest part is and shade this as dark as possible. Then decide where the lightest gray is. Divide the area between the lightest shade and the darkest shade into four, and graduate the shading accordingly.

The other type of shadow is "cast" or "projected" shadow. A cast shadow is that area that light cannot get to because there is an object in the way. Because light travels in a straight line, a cast shadow's shape is a version of the shape of the object that is casting the shadow. Draw around the cast shadows on your still life and you will notice that there is no variation in the darkness of a cast shadow. If there is, this variation is caused by light reflected off an adjacent object and shining into the shadowed area. Without altering the still life arrangement, change the position of the light, and draw the same subject matter again in the same way. Notice that all the patterns and shapes in your second drawing are very different from those in your first.

Above: *Monochrome photographs are a good way to see all the tonal values of the objects you wish to draw.*

How do I arrange a still life?

In general, a still life should not look too "posed," but should aim for the casual look that can be achieved only by careful arrangements of objects. Most still life artists spend a considerable amount of time considering the options before starting a drawing, experimenting by bringing in objects, removing others, and adjusting groupings.

For the beginner it is always best to start off with a limited number of objects – perhaps no more than five or six – and to arrange them in a simple composition (see page 188). In choosing the objects for your drawing, pay special attention to the contrast and balance of different textures, so that you can juxtapose smooth with rough, shiny with matte, and hard with soft. The more visual excitement and contrast you can introduce into the subject, the better. But do not overdo it; too many contrasts and dramatic juxtapositions will tend to confuse the viewer.

Right: *Machine-made and natural forms create interesting patterns.*

How can I use graphite pencil alone to draw a successful still life?

By using this flexible drawing substance, that can be erased without trace if necessary, you have a responsive medium for examining the two-dimensional layout and the three-dimensional structure of this common still life subject. A 2B graphite stick provides quick covering power, and for subtle effects, apply graphite powder with a torchon or brush. If you block in the tones softly, you will have a preview of the composition before you draw a line. A drawing-grade pencil, such as a 2B, gives the precision required for definition and detail work later.

Graphite pencil

1 First, block in the dark tones and shadow shapes. Linear drawing makes this difficult, so until you become more practiced at drawing line and tone together, draw the tone first using graphite powder applied with a torchon.

2 When you are satisfied that the tonal work is describing the plant's three-dimensional character, use a pencil to define the structure. This is the main divisions between the pot, the leaves, and the negative shapes between them.

3 Reinforce the deepest darks and clean up any light values that may have been shaded over. Fix the particular shapes of leaves, or the group shapes they make if you have decided against drawing every one. Check the perspective of the plant pot; it can still be amended at this stage.

4 Graphite is easily smudged, so check thoroughly to make sure that you clean up any blurred forms by removing the unwanted smear with an eraser. To finish, refresh richer lines and tones that have been softened by smudging, and fix lightly.

How can I bring added interest to a simple still life subject?

Introducing a "special" drawing technique into your work can add another dimension to a still life. Here the striations on the translucent layers of onion skin are an ideal pattern to depict using impressing (see page 22).

(see page 22)

ARTIST'S TIP

When impressing, it is important to envisage the final structure of the color composition before you start working, because impressed lines are not easy to remove or disguise.

Graphite and colored pencil

1 After outlining the form of the onions on the drawing surface in brown pencil, lay tracing paper and, with a graphite pencil, draw the lines of the onions, pressing hard on the paper.

2 When the lines are all drawn, remove the tracing paper to reveal a network of indented gullies in the paper. These impressed lines will alter the visual effects of any colored pigment applied later.

3 Add greens and browns to the forms; apply them parallel to and across the impressed lines to exaggerate their appearance.

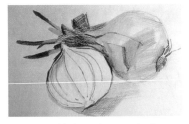

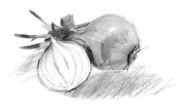

4 As you add more pigment, the lines will become more dominant – only where color is very heavily pressured does it penetrate the impressions.

5 The finished drawing shows how color and form can be emphasized with impressed lines. The lines on the halved onion parallel the contours on the skin of the whole onion.

How do I draw glass and its reflections?

The first thing to remember about drawing clear or colored glass is that objects that can be seen through the transparent glass may distort, blur, or soften the glass surface. Also remember that all light is reflected on the surface of the glass, and any surrounding objects will also cast their color onto it and influence the effect further. Drawing glass therefore requires a close study of tonal and color values; it may be worth sketching some initial studies in your sketchbook before attempting your final drawing.

Soft pastel

 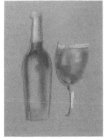 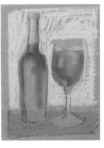 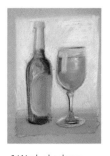

1 Take care when making your initial drawing – it is difficult to make each side of the bottle and glass the same as the other.

2 Start to build up color, using your finger to smudge and blend a number of colors together and work areas of lights and darks.

3 A light background defines the dark shapes of the glass and bottle, emphasizing the tension between them – they are similar, but the glass is smaller and rounder.

4 Work shadows and reflections on the glass and bottle. There is nothing mysterious about reflections; just keep looking hard to see where highlights should go.

Left: *Using a dark color to put in shadow on the stem of the glass.*

How do I create accurate perspective in a cylinder shape?

Students often have difficulty drawing circular and cylindrical objects in perspective. There is a simple rule that can help you here – circles fit into squares. So once you can draw a tabletop or box, you call draw a circle or cylinder. The other important thing to remember is that circles, like rectangles, change shape according to viewpoint. The photographs show how perspective makes the circles appear to be ovals, usually called ellipses, and also how the shapes of the ellipses change according to where they are in relation to your eye level.

Left: *Circles and ellipses are the bugbear of many drawing students – and some professional artists. Remember that they change according to your eye level, so take care to keep a consistent viewpoint as you work. You will also find it much easier if you mark the center first, and measure each side on your drawing to make sure both are equal.*

Pencil, ink and wash

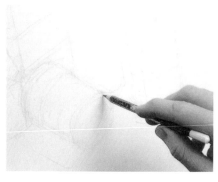

1 First indicate the positions of the objects using a pencil.

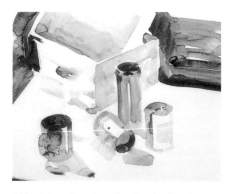

2 Use ink and wash to develop the drawing and reestablish the shapes of the ellipses.

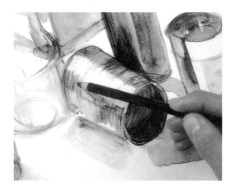

3 Now use pencil to give the objects more definition as well as to build up an interesting surface in this mixed-media drawing. Then use pencil and wash to develop the drawing.

4 Notice the differences between the top, middle, and bottom ellipses of the glass jar, which are shallow at the top and become progressively rounder.

How can I capture interior light?

Compared with outdoor light, interior light sources are more readily controlled by the artist, although it is often a chance effect of daylight entering a room that provides the idea for an effective still life. However, there can be great variety in the color quality and intensity of the light, depending on whether it comes from a natural or artificial source. Whereas you may have strong natural light at a window, the level falls quickly farther into the room.

Left: *The artist describes brilliant light from a large window complemented by a smaller pool of lamplight focused on the shadowed work area. These provide interesting patterns of light and shade enhanced by the slatted blind drawn down over the window.*

Left: *These studies deal with the enclosing effect of concentrated lamplight, which draws in the space of the room and creates a warm glow.*

What should I consider when drawing flowers?

Varied textures, colors, and shapes all make plants and flowers one of the most attractive and challenging artistic subjects. You can choose to create a simple study of a single flower, or, at a more ambitious level, you might decide to draw a complex, sprawling ivy or a complicated flower arrangement.

Whichever you choose, remember that plant drawing is a mixture of still life and natural history. Obviously, you can set up many subjects in the studio, but at the same time, you should never forget that what you are drawing is a living thing and should be rendered as such. One of the best things to try is putting the plant into the most natural setting you can find. The surrounding colors will make the final study more sympathetic.

Above: Kay Gallwey, pastel *This is a wonderfully spirited pastel that captures the Provençal brilliance of the flowers.*

ARTIST'S TIP

Try investigating the structures and patterns in natural subjects that are indicative of their growth and function.

How can I use lighting effectively in a floral still life?

Lighting can be used to great effect in drawing floral still lifes. Here, an almost monochromatic scene has been injected with life by a shaft of light piercing through the window. The vivid purple and yellow of the iris flowers positively glow in this cool room where time seems to stand still. Beyond is the hint of a warmer world – inside, large cold spaces take their life from the texture of the artist's hatching only.

Reference photograph

Graphite and colored pencil

1 Sketch in the basic framework of the picture in deep gray, then concentrate on the focal point – the flower heads – working up the intricate color planes. Use ultramarine, dark violet, light violet, and Prussian blue.

2 Apply color to the flowers using broad, strong strokes, starting with the palest color and working through to the darker hues. Leave spaces for the finishing highlights of Naples yellow.

3 The monochromatic background is too plain to be treated as a flat expanse of one color, so apply a complex stroke pattern of hatching and crosshatching to create texture within the color.

4 Treat the large areas of hatched background above and to the left of the vase of flowers as balancing areas of tone within the composition, pivoting on the diagonal.

5 Substantiate the visual balance by balancing the vase of flowers on the "fulcrum" on the table. Beneath the table surface, add a dark area of crosshatched black as a balance to the dark hues in the greenery of the flowers. Create the hard edge of the table by hatching against a ruler.

What is the process for drawing a still life with watercolors?

It is possible to "draw" a still life in watercolor using a signwriter's brush; this is a particularly suitable method for depicting the flowing shapes of flowers and leaves. Use the same technique as when drawing in pencil, but remember that wet lines will smudge. It is possible to achieve a great variety of line – from thick to very thin – and a wider range of darks and lights than when drawing with pencil.

ARTIST'S TIP

Help nature help you by making sure that any plant or flower you draw remains in peak condition for the entire time it is on your drawing board.

Reference photograph

Brush with watercolor

 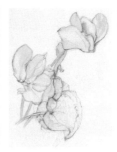

1 Start to make your exploratory drawing, using a signwriter's brush and watercolor. Use very faint, dilute color to begin with and gradually work up the strength of the line.

2 Continue to look for the form of the plant rather than the actual pattern on it. Remember that when you go over areas again, it is necessary to let the paint dry first.

3 A light wash helps to distinguish between the two areas, leaf and flower. Continue working and reworking the line of form to suggest internal shapes.

4 Strengthen the washes to introduce more color. Make the foreground shapes darker and wash out color with water to make less important areas recede.

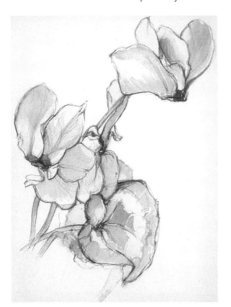

5 The finished drawing of this cyclamen shows how the use of watercolor has produced a finely rendered version of the finished form. The basic drawing is carried out in the same way as you would if you were using a pencil and enables you to establish both basic shapes and work out the finer points of detail. The washlike treatment of flowers and leaves gives the subject that added touch of life that is the hallmark of all good plant and flower drawing.

9

APPROACHES
AND STYLE

What differentiates a drawing from a painting?

It is nearly impossible to mark a clear dividing line between drawing and painting. Traditionally drawing has been seen as a preparatory stage leading to a finished work in another medium, but at least since the late nineteenth century the distinction between drawing and painting has become blurred.

Before then, drawings – generally in monochrome – would be made from life and a painting developed from them. The Impressionists, however, by painting directly from their subjects, combined drawing and painting in a new expressive way. For example, Impressionist Edgar Degas (1834–1917) broke with the tradition that had favored highly finished portraits in carefully blended colors and tones. He experimented instead with pastel to exploit the link between painting and drawing, using water or white spirit to dilute the pigment so he could spread it as a wash or paste of color.

Subsequently artists have been free to use color as an integral part of drawing. Drawings are no longer always seen as a means to an end: They can be, but they can also be complete works in themselves. There are no set rules about which media are exclusively for drawing and which for painting. Just as you can draw with a brush, you can paint with pastels, colored pencils, or any dry colored medium. Essentially, the outline shapes in drawings are constructed with lines, whereas those in paintings are modeled with tonal applications of varying colors and values, but this distinction is still open to interpretation.

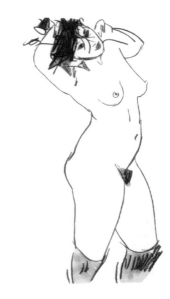

Above: Kay Gallwey, pastel *In this pastel drawing only line has been used, drawn decisively with the tip of a black pastel stick. It is surprising how much can be conveyed about form by the subtle variations in the weight and direction of the lines used in such a drawing.*

How can I develop a personal drawing style?

Your artistic style should be personal – watching others can reveal useful techniques and approaches, but this is of limited assistance, because style cannot be adopted secondhand. The ways to develop a personal style include maintaining an original and innovative response to what is seen, together with the choices of appropriate techniques, design selection, tone and color organization, and experimenting with new ways of mark-making to create an image. When you recognize your own style emerging, you can adapt it by adjusting the choices you make.

In developing your own style, there is no need to seek the extraordinary or bizarre as a way of creating something new, although in the course of your progress you may come across a vision so compelling that you want to interpret or record it. Until you are sure of your preferences, turn to the evergreen subjects that preoccupy artists – still life, landscape or townscape, and figures.

The subjects may be standards, but the new factor is you, with all your characteristics, aptitudes, and persuasions. You are the person who makes the drawing, so reflect in it your unique combination of qualities. Let others influence your work, but as an inspiration, not a stylistic restraint. Be brave enough to follow your intuition if you feel impelled to draw in a certain way.

After this you will start to see progress, because your instincts are your best guide to developing your own unique, personal style. The drawing that results may not be a complete success, but within it will be the harbingers of future work and technical innovations to build on for a new approach.

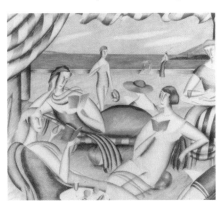

Left: *Seaside*, Catherine Denvir
Above: *Men in white*, Sally Strand *These two interpretations of figures have much in common, even though each is recognizable as the work of a particular artist.*

How can I express an inner vision in my drawings?

Drawing is the most direct means of communication available to the artist, and it is possible through it to release the imagination and to make drawings of an inner world. The popular concept of the artist is that he or she works entirely from imagination, but in reality the great majority of artists, even those whose work is abstract, usually work from direct experience of the external visual world. For some, however, the inner landscape provides a fascinating vista, and it is one worth serious exploration.

Imagination in art has often been used to take the artist from the mundane concerns of the present day to the idealized world of the past. Subjects were taken from history, particularly the medieval period, but this celebration of the past had little to do with the historical reality; artists tried to re-create a past that they wished they could inhabit in the present.

> **ARTIST'S TIP**
>
> When we admire a realistic drawing and wonder why we had not thought of drawing that particular subject or seeing it in that way, what we are admiring is the artist's imagination.

Imagination and a subject

It does not follow, however, that drawings from everyday subjects must by definition be unimaginative. If someone who knows nothing at all about drawing and painting were to see two or three artists drawing the same subject, they might wonder why each one is making quite different marks in response to it. Some part of the difference between artists' drawings of the same subject must come not from the subject itself but from what the artist brings to it. This might include knowledge and experience, but it also includes imagination.

Artists are by nature inquisitive people, and they can discover strange features and unexpected associations by closely studying the character of things. Just as you can see pictures in the fire, so you can place things from one context into another, working on the "what if?" principle. The most ordinary object or location needs very little manipulation to turn it into something from another world.

Left: *Flaming tea strainer,* **David Cuthbert, colored pencil** *The artist makes excellent use of the qualities of colored pencils to give a dazzling account of this imagined event, with the intense blue background providing a brilliant contrast for the orange flames. The artist has felt free to change the relative sizes of the strainer and teapot and to distort the shapes.*

Is it possible to draw from memory?

Many people feel they could not draw anything without having it in front of them, but visual memory can be improved by training yourself to memorize shapes, tones, and colors. This is useful, as drawing from memory is sometimes the only means by which a subject can be re-created. When you draw a moving figure or animal, you can do so only by remembering them in one particular position.

If you spend five minutes looking at an object, you will have to not only retain a number of images in your mind but also organize them into categories of relative importance. When you start to draw, you will find that although the absence of the objects has the advantage of preventing you from copying irrelevant details, it can also make it very difficult to recapture them precisely.

Joseph Mallord William Turner

Turner was a prolific artist whose visual memory was exceptional; he claimed to be able to remember the exact look of the sky during a storm in the Alps long after he had seen it. An eyewitness account from a train passenger in England records how Turner thrust his head out of the open window of a stationary train and kept it there for several minutes in a howling gale. This was to fix in his memory a scene which he later re-created in his famous painting *Rain, steam and speed*.

What are some aids to drawing from memory?

You can prompt your memory if you combine it with rapid note-making. On occasions when it is impossible to make a considered drawing of a place, person, or event, a few quick notes can be made to act as a reminder of what was important about the subject. These may be scribbles on the back of an envelope, or the main shapes of the subject quickly drawn in a sketchbook with some accompanying written notes. The simple act of drawing, however rapidly or roughly, helps to commit a scene to memory in a way that simply looking does not.

As an exercise, get someone to pose for you for not more than five minutes, and try to fix their features and characteristics in your mind – the shape of their head, the form of their nose, their particular kind of chin and lips. Then make the most detailed drawing you can from memory. Try to avoid making it look like a police composite picture, where each feature looks as if it has been remembered separately. Close your eyes from time to time and see the subject in your mind's eye – this is another effective memory exercise.

When I cannot think of what to draw, how can I get inspired?

Although it may seem contradictory, drawing can be a means of discovering things to draw. If you are ever stuck for a drawing subject, the best advice is just to start drawing – anywhere and anything. The French painter Pierre Bonnard (1867–1947) was a compulsive draftsman. He took a pencil and a scrap of paper everywhere he went, but he was particularly adept at discovering new subjects (or new things to say about old subjects) in his immediate surroundings. By continually investigating the visual world, you will constantly find new

things to say. Indeed, the Japanese artist Katsushika Hokusai (1760–1849) wrote about this never-ending search, claiming that all he had produced by the time he was seventy years old was not worth taking into account. "At seventy-three I have learned a little about the real structure of nature," he wrote. "In consequence when I am eighty I shall have made more progress; at ninety, I shall penetrate the mystery of things; at 100 I shall have reached a marvellous stage; and when I am 110 everything I do, be it but a dot or line, will be alive."

Left: Paul Bartlett, oil pastel *A very ordinary subject has inspired a most dramatic oil pastel drawing. The sleeves of the jacket, looking almost like elephants' trunks, have been simplified into a contrasting pattern of light and dark, which gives an excellent feeling of the tough, thick material. Notice how the artist has used the pastel stick to follow the folds and creases around the sleeves, collar, and pockets to create a feeling of three-dimensional form.*

What is a working drawing?

Whereas sketching is usually used for quick studies and exploring ideas, drawings that are made specifically as a step toward a work in, most likely, a painting medium are often called working drawings and tend to be more detailed. Drawing is very important in relation to painting because it is the quickest way to respond to a visual idea; a few lines, drawn in as many seconds, can effectively conjure up the first idea of a painting. Drawing is much more useful than taking a photograph, because to make any drawing you have already had to decide which aspects of the subject are significant and commit them to paper. Working drawings may not always have any great merit in themselves, sometimes acting simply as an aide-mémoire to jog the memory into recalling a particular visual incident rather than actually describing it.

Transferring a working drawing

You may often wish to translate the forms and characteristics of your working drawing directly and accurately to the surface of your larger finished work. To transfer a working drawing into a larger one on the paper surface, make a grid of squares on the drawing and a larger one on the painting surface. Then copy the information from one to the other.

Right: Bruce Cody, pencil *This working drawing has been squared up for transfer.*

How should I examine a subject to determine if it will make a good painting?

A drawing from which you intend to develop a painting should first be an investigation of the subject, testing its potential for painting. It is a kind of rehearsal, with the marks in your drawing anticipating the marks you believe you will later make with your brush. You must restrict yourself to recording only information from which you can paint. Sometimes you may create an effect that looks perfect in the drawing, but if it will be impossible to reproduce it in paint later, you must reject it. On other occasions you may be tempted to leave something out if the drawing looks all right without it, thinking it will not be needed in the painting. If in the slightest doubt, however, be prepared to ruin the drawing in order to have sufficient information from which to paint.

ARTIST'S TIP

It is possible to make a painting from a single drawing, recording in it information about shapes, tones, and colors, including written notes. Sometimes, however, it is better to make separate studies of shapes, tones, and colors.

Left: *Wrapped urn and trees*, Joyce Zavorska, pencil (above) and print (below) *The graphite drawing is one of a series of study sketches exploring the possibilities of the subject for the monotype print below. Some artists will make just one drawing, whereas others will spend several working sessions making preparatory investigations of this kind.*

How do I record shapes in a working drawing?

Once you have decided on your subject, your first priority should be to visualize the main shapes in your painting. If after your first attempts at recording these, you think your drawing is too small to include everything, extend it by joining additional pieces of paper as necessary or, if you are working in your sketchbook, by drawing on to the next page.

Do not let the dimensions of the original sheet of paper dictate the outcome of the drawing, even if this means that you end up with a drawing larger than your board. You do not need to decide where the edges of your picture will be until you start work on the painting. Pencil, charcoal, or a pen are ideal for this kind of drawing.

How do I record color information in a working drawing?

Some artists write notes about color on their drawings. This is very useful, but only when you have learned how to describe colors. Merely writing "blue," for example, is not going to be much use when you begin to paint. "Warm blue" or "purple blue" would be better, and "prominent warm blue" or "receding purple blue" even more informative.

To be effective, a color note has to tell you what you need to know to re-create the intended color. Color notes can be written on the appropriate places in your drawing or around the edges with lines pointing to their positions if necessary. You can also make colored drawings, but these also have limitations unless the same medium is used for both drawing and painting.

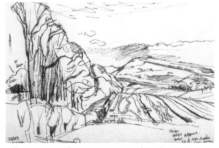

Above: Gordon Bennett *This drawing, although rapidly executed, includes a series of color notes and contains all the information the artist needs to construct his landscape painting.*

Is there a quick method for recording visual notes?

Because drawings for paintings are only a step in a process, they need to mean something only to the artist. Through experience, artists learn which information they can retain in their memory and which they need to record, and they often develop a shorthand.

A quick method of making visual notes is extremely valuable, first because it enables you to record something that might soon change, like a particular atmospheric effect, and second because it enables you also to draw in inconvenient places, where speed is of the essence, perhaps on the steep bank of a river or near a busy main road.

It is only through experience that you will develop this kind of expertise, but there are some well-tried methods for recording information on tone and color. I have already mentioned making written color notes (see page 209), and many artists also have their own system for numbering tones. Tones can be numbered from lightest to darkest or in the reverse way.

ARTIST'S TIP

If necessary, write notes on the drawing about the tone plan as well, perhaps describing the over-all effect or identifying particularly dark and light areas.

Above: Arthur Maderson *Looking at this drawing it is hard to believe that a painting could be made from it, but the artist has developed a highly effective personal "code," numbering the colors and tones, and sometimes also writing more elaborate notes on his sketches.*

What is a grisaille drawing?

Dating back to the seventeenth century, grisaillle is a method whereby the artist tints the drawing or painting surface as a base for color work. Once the tint has been applied, the artist models the subject in monochrome tonal values (usually a range of grays) in the medium in which he or she is working – whether it be wet or dry. This tint is considered the underpainting.

The advantage of this modeling process is that the artist works with tonal values alone, from light to dark, to create depth, form, and volume. These graded values help establish the subject's shadows, mid-tones, and highlights to create a three-dimensional appearance on which to develop the colored drawing or painting.

You can actually call the drawing complete at the tinted stage and leave it as monochrome. However, grisaille's purpose is to use the tint as a base for color work. When color is subsequently applied over the tint, there is no need to assess and describe the values of the subject through the application of color.

Above: *You can see in the black-and-white version of this still life that the fruit is three-dimensional and that a variety of grayed values create its form. The next step is to add colored pencil to the grisaille underpainting using various hues of color, as shown.*

What is a narrative drawing?

A still life, landscape, or portrait drawing is self-explanatory; you know it represents a vase or a tree or a person. However, a narrative drawing is one that creates a scenario to imply a story, message, or idea. This type of artwork can be very intriguing to viewers and make them linger to think about the meaning of the piece. A narrative drawing is usually introspective and rife with symbols, metaphors, and meaning; these are sometimes apparent only to the artist. The inspiration can be anything from a "slice of life" to a memory or a dream – or it can simply be a piece of fantasy plucked from the artist's imagination.

Above: *The diva retires*, Vera Curnow, colored pencil *This piece is an example of a narrative drawing in that it presents a story or message. It is not important that the viewer understand it, but the title provides a clue. The artist chose to keep the intent of the drawing ambiguous, leaving it to the viewer to interpret. There is much symbolism within the content, and this is not, obviously, a representational piece of art.*

What is an open-ended drawing?

A drawing can be begun with no preconceived notion about either what it is to include or what its ultimate purpose will be. This open-ended approach to drawing is seen in its most obvious form in doodles and similar kinds of spontaneous drawings where the drawing is given a life of its own and allowed to develop as it will.

Chance effects created in this kind of drawing may be exploited only to be discarded later if another accidental effect is preferred. Drawing from a particular subject can be just as much concerned with discovery. The subject can be used only as a starting point, and the drawing then allowed to develop its own momentum without being constantly compared with the subject.

There are, however, many other open-ended ways in which drawings can be made from the visual world. If a subject excites you, you will be trying to identify the elusive features that create this excitement when you draw it. Or you may start to draw something that does not particularly appeal to you at first, searching for some arrangement of shapes and forms that will suddenly intrigue you.

Even if you have not started to draw with the idea of inquiry at the forefront of your consciousness, you will often make discoveries when drawing. You may begin a drawing feeling sure of what is important about the subject and how you will translate it, but less certain of the best possible composition. In trying to decide the best composition, you may discover aspects of the subject that are much more significant than those you had identified at first.

What is trompe l'oeil?

This is a French term (pronounced trump-loy) that means "deception to the eye"; it is also sometimes referred to as photorealism or illusionism. The term describes a type of drawing that is created so realistically that it may fool the viewer into thinking the objects or scenes represented are real or a photograph. In fact, viewers will often reach out to touch the object, believing it is real.

Trompe l'oeil in drawing requires a high degree of precision and skill, and it is worth attempting a work in this style to improve your own observation and drawing skills. Such a piece will take a great deal of practice to achieve the high level of accuracy required, and most artists drawing in this style work from life. If you would like to see an outstanding example of trompe l'oeil,

the art of Michelangelo (1475–1564) in the Sistine Chapel was achieved through a complete mastery of perspective.

Right: *Brownie girl*, **Beverly Ferguson Deevy, colored pencil** *This portrait of a young girl is almost photographic in its rendering. Strong side lighting, as used here, can be very effective in revealing creases and folds in materials. Using a close range of browns and yellows, the artist has lovingly described each dip and undulation of the girl's uniform. Notice also how she has captured the subtle tones of the folds in the white blouse, where the shadows are illuminated by reflected light.*

What can I learn from decorative art?

The study of natural form can lead to decorative art, where the motifs of natural objects are the main subject matter. Look around any home and you are almost certain to find curtains, wallpaper, or furnishing fabrics that in some way use leaf or flower patterns, originally inspired by and derived from studies of natural form, irrespective of how abstract these patterns may have become. In the decorative arts the visual significance is far more in the overall pattern than in the individual objects, and it is through decorative arts that a beginner can gain experience and understanding of abstract images.

The stylistic approach of the Art Nouveau movement of the late nineteenth and early twentieth centuries shows some wonderful examples of the use of natural form in the decorative arts. This particular style affected all areas of the visual arts from architecture to fabric design, electrical appliances, wrought-iron work, couture fashion, and furniture. It was one of the first styles to be purposefully created that directly affected, in such a broad manner, all sections of society at more or less the same time.

If you are interested in this style of art, make a first attempt at creating a

pattern by trying to design a frieze or decorative border. Draw a simple leaf motif that repeats itself; this will require you to draw the motif in such a way that the beginning and the end of the pattern match, so that the whole motif repeats itself in an uninterrupted and continuous flow. After a few attempts you will probably end up with something reasonably simple and attractive, a pattern that could be cut out and used as a stencil to personally decorate your furniture or a room. You can then start to work on more elaborate pieces.

Left: ***Whippet,*** **Vera Curnow, colored pencil** *Here, natural motifs provide an effective background to this drawing of a whippet. Notice how the individual motif elements fit seamlessly together to create a flowing whole.*

What can I learn from cartoons?

Cartoons have something vital to teach us about obtaining a likeness. The word *cartoon* (from an Italian one meaning "a large sheet of paper") originally referred to a full-size drawing for a painting or tapestry, complete and ready for transfer to the working surface. The word is still used in this sense, but to most people cartoons are the humorous or satirical drawings that are featured in almost every newspaper or magazine.

They are usually concerned with public figures whose appearance is well known, and although they are instantly recognizable, they really look nothing like the actual person. They are not convincing in the way that a portrait painting or drawing is, and will mean nothing unless you are familiar with the person's real appearance. Nevertheless they provide a kind of likeness, often with great economy of means.

In most cartoons a particularly characteristic feature – a distinctive nose, bushy eyebrows, or large ears – is exaggerated, becoming the main feature in the drawing, with most other aspects of the person's appearance ignored. Selecting and exploiting a telling feature of a person – although in a less exaggerated way – plays a significant part in obtaining a likeness, and you will need to look out for what is most obvious in terms of features, the shape of the head, and so on.

When we draw a landscape or urban scene, we seldom worry as much about creating a "likeness" as we do when drawing a person. Yet all the things that should be considered in drawing a portrait are equally important when tackling other subjects such as landscape and still life. Not all depictions of figures aim to make the people recognizable; what they are doing may be more important than who they are. In the same way, not all landscapes are intended to be portraits of a particular place.

Perhaps one of the advantages of landscape painting is that a number of different experiences of a landscape can be brought together to convey a feeling for a place rather than a literal description of an actual view. If you are drawing a particular view, you can treat it very much as you would a portrait, exaggerating some features and ignoring others, but the drawing will be convincing only if it has a "sense of place," which is in many ways the equivalent of the "likeness" in a portrait.

> **ARTIST'S TIP**
>
> Perhaps what characterizes all good works of art is that they are utterly convincing.

Above: *St. Ignatius Sunshine Committee*, **Vera Curnow, colored pencil** *This whimsical cartoon drawing of dour women belies the title. The artist exaggerated the facial features, which were made from her imagination.*

What can I learn from caricatures?

All portrait artists know the value of the caricature; the element is contained in all good likenesses. Unlike a cartoon, a caricature is done of a real person and should be reminiscent of their features or personality traits. The art is an extremely ancient one, many artists over the centuries having created caricatures along with their other work. Traditionally, the caricature has been seen as a political art form, closely associated with social comment and criticism. Frequently, too, it is associated with humor – indeed, it is often attached to an intended smile or guffaw. The drawings usually tend to be in pen and ink, or brush and ink, largely because of the demands of reproduction; however, both pastel and pencil lend themselves readily to the art form.

Your main task when drawing a caricature is to extract the essential character from your subject by selection and emphasis. Often, these changes are of a very subtle kind, despite the popular notion that most caricatures are extreme in their distortions. A successful caricature preserves a balance between reality and exaggeration; it retains a strong feeling of identification with the real world, yet underlines the features that best express the individual.

What is abstract art?

Abstract art is based on the belief that shapes, forms, and colors have intrinsic aesthetic values and thus do not necessarily have to relate to a real subject. Some twentieth-century artists found drawing and painting what they saw was too restricting. They looked to music and saw that it could exist as an art form capable of communicating in all kinds of ways without imitating natural sounds. Why then, they asked, should art not also be able to exist in a similar way, independent of representation?

In a sense, abstract art has always existed, often as decorative pattern.

In Muslim culture, for example, where representations of the human figure are forbidden, abstract art has been developed to a level of great beauty and expressiveness. Even in Western art, where the emphasis has been on depicting what is seen, there is often an element of abstraction, which is more pronounced in some artists than in others.

It was in the nineteenth century, however, that a more urgent exploration of nonrepresentational art developed. There were two main reasons for this experimentation. First, invention of

photography seemed for a time to make representational art redundant, and second, artists began to realize that the main aim of Western art – depicting what we see – was one that was impossible to achieve. We know now that we cannot be completely objective and separate what we see from what we know. We recognize that there are different ways of seeing, and we do not regard this as a disadvantage.

The experimental art of the modern era has taken two main routes. One has been that of communicating the artist's feelings, whereas the other takes the formal arrangements of shapes, forms, and colors as the artist's actual subject. On the formal route, the way divided again into two different directions, one of which I will call "pure" abstract art, which has no external visual starting point in nature. The other direction, which I will call "abstraction" (see below) took from the visual world those things that would create interesting and unusual effects in an artwork, regardless of whether they helped to give a sense of reality.

A good place to start making abstract drawings is with still life subjects, as the Cubists generally did. You may like (as they did) to use bottles, musical instruments, and other objects with clearly defined shapes. Study the work of Pablo Picasso (1881–1973) for further ideas and inspiration.

How can I achieve abstraction through drawing?

Abstraction (see page 217) simply takes from a subject those shapes, forms, and colors that have the greatest pictorial significance. When you are abstracting from nature, you do not have to worry about whether your drawing looks realistic; indeed you can select and exaggerate shapes, forms, and colors until the subject is completely unrecognizable. Most people find it difficult to draw anything without creating an illusion of reality, so you may find it easier to work from a drawing you have made previously. Make another drawing from the first one, extracting the important shapes, forms, textures, and tones.

One way to do this is to lay tracing paper over the first drawing and trace on it the shapes and forms you think are important. Then transfer these to a sheet of drawing paper to develop the work. If working directly from a subject, start by blocking in the main shapes with tone or color and develop your drawing by selecting and exaggerating the shapes,

forms, and colors (if you are using color) that you see as significant. You may need to turn away from the subject periodically and develop the drawing independently of it, as otherwise you may find it impossible to prevent yourself from describing it realistically.

Right: *Skull form,* **David Ferry, pencil** *A bird skull has been the inspiration for a bold drawing that contrasts clearly defined shapes and light and dark tones. The artist has also compared the foreground organic forms with forms in the background that have been given an architectural quality.*

Above: Pip Carpenter, carbon pencil and wash *The close-up view of these rock formations accentuates their abstract qualities, and the rugged character of the subject has been translated by drawing line over line almost as if the artist were carving the drawing.*

Glossary

Aerial perspective

The effect of tones and colors becoming paler as they recede, with diminishing light/dark contrasts to convey a sense of space.

Binder

Any medium that is mixed with pigment to form paints, pastels, or colored pencils.

Blending

Achieving a gradual transition from light to dark, or merging one color into another. Pastels are often blended by rubbing two colors together with the finger, a rag, or a torchon.

Burnishing

A technique used in colored pencil drawings, in which colors are rubbed into one another and into the paper with a torchon, plastic eraser, or white pencil. Because burnishing irons out the grain of the paper and compresses the pigment, it imparts a slight sheen to the surface and increases the brilliance of the colors.

Charcoal

Charred twigs or sticks used for drawing, and particularly suited to broad, bold effects.

Complementary colors

Pairs of colors that appear opposite each other on the color wheel, such as red and green, yellow and violet, and blue and orange.

Conté crayon

A hard, square-sectioned crayon stick available in black, two browns, and white.

Contour

In a map, the contour is the outline of a mass of land, and the meaning of a contour line is very much the same in drawing. Contour must not be confused with outline, which only describes the two-dimensional shape of an object, whereas contour lines add the third dimension.

Crayon

Sticks of color made with an oily or waxy binder and used in wax resist.

Crosshatching

A method of building up the tones or colors in a drawing with crisscrossing parallel lines.

Depth

The illusion of three-dimensional space.

Foreshortening

The optical illusion of diminishing length or size as an object recedes from you.

Golden Section

A system of organizing the geometrical proportions of a composition to create a harmonious effect. It has been known since Classical times, and is defined as a line (or rectangle) that is divided in such a way that the smaller part is to the larger what the larger is to the whole.

Graphite

A form of carbon that is compressed with fine clay and used in the manufacture of pencils.

Hatching

Building up tones or colors by means of closely spaced parallel lines; the closer they are, the more solid the tone or color. When a further set of lines is laid on top, going in the other direction, the technique is called crosshatching.

Horizon line

Imaginary line that stretches across the subject at your eye level, and is where the vanishing point (or points) are located. The horizon line in perspective should not be confused with the line where the land meets the sky, which may be considerably higher or lower than your eye level.

Lifting out

This method is most used in painting, particularly with watercolor, but is also a charcoal technique. Darks are laid down first, and the highlights and mid-tones achieved by removing areas of charcoal with a kneaded putty eraser.

Linear perspective

The method of creating the effect of recession through the use of converging lines and vanishing points.

Local color

The actual color of an object, regardless of particular lighting conditions. The local color of a lemon is yellow, but the shadowed side may be dark green or brown.

Medium

1. The material used for drawing or painting, i.e., pencil, pen and ink.
2. Substance added to paint, or used in its manufacture, to bind the pigment and provide good handling qualities. To avoid confusion, the plural is usually given as *media* for the first meaning, and *mediums* for the second.

Pastel

Sticks of color, either cylindrical or square-sectioned, made by mixing pure pigment with gum tragacanth.

Picture plane

The plane occupied by the physical surface of the drawing. In a figurative drawing, most of the elements appear to recede from this plane.

Pigment

Finely ground particles of color that form the basis of all paints, pastels, and colored pencils.

Receding colors

"Cool" or muted colors that appear to recede to the back of the picture plane, whereas the bright, warm colors come forward.

Sgrafitto

Scraping back one layer of color to reveal another one – or the color of the paper – below. The method is often used in oil and acrylic painting, but in drawing, the only really suitable medium is oil pastel.

Shading

Graded areas of tone describing light and shade in a drawing.

Sketching

This has taken on an outdoor connotation, although in fact a sketch can be any drawing that is done quickly and not taken to a high stage of completion.

Spray fixative

Thin varnish sprayed on to charcoal or pastel drawings to prevent them from smudging. Spray fixative is often used at various stages in a drawing.

Stippling

Building up areas of tone by means of small dots.

Support

The term applied to any material, whether paper, canvas, or board, that is used as a surface on which to draw. The word is more common in the context of painting than drawing.

Tone

The lightness or darkness of any area of the subject, regardless of its color. Tone is related to color only in that some colors are naturally lighter than others. Yellow is always light in tone, and purple always dark.

Tooth

The term for the grain of textured papers, which "bites" the colored pigment or pastel dust and helps to hold it in place.

Torchon

A rolled paper stump used for blending in pastel work and sometimes also for burnishing.

Value

Another word for tone, used particularly in the United States.

Vanishing point

In linear perspective, the point on the horizon line at which receding parallel lines meet.

Wash

Diluted ink or watercolor, applied with a brush. Washes are often used in conjunction with linear pen drawing.

Wax resist

A method based on the incompatibility of oil and water. If marks are made with a candle or waxy crayon, and ink washes – or undiluted ink – applied on top, the wax repels the water.

Index
*Page numbers in **bold** refer to illustrations.*

Acknowledgments

The material in this book has previously appeared in the following:

Successful Sketching by Valerie Wiffen
The Complete Drawing Course by Ian Simpson
Drawing & Sketching by Stan Smith
Introduction to Drawing by John Jackson
Essentials: Drawing Companion by Viv Foster

The publishers would like to thank all the artists whose skillful work is included in this book.

Unless otherwise indicated, images are the copyright of Quantum Publishing.

Key: top (t); bottom (b); left (l); right (r).

7 Vera Curnow. **11** Vera Curnow (r). **17** Vera Curnow (b). **18** Vera Curnow. **19** John Townend (t). **26** Joan Elliott Bates. **30** Viv Foster. **35** Leonard Leone (b). **41** Julie Joubinaux. **47** Eric Brown (t). **62** Paul T Bartlett. **71** Alan Oliver. **84** Judy Martin (b). **98** John Houser. **100** Martin Taylor. **103** Claire Belfield. **107** Vera Curnow. **108** Stan Smith (t), Valerie Wiffen (b). **109** Sarah Adams (b). **110** Stan Smith (t), Ronald Jesty (b). **111** Richard Kirk. **113** Vera Curnow. **115** Elizabeth Moore. **119** Karen Raney (b). **120** Tony Coombs. **121** John Denahy (l), Paul Bartlett (r). **123** Ian Simpson. **124** David Carpanini (t), Kay Gallwey (b). **125** Diana Constance (t), Robert Geoghegan (b). **127** David Carpanini. **141** David Ferry. **142** Viv Foster. **143** Philip Wildman. **148** John Elliot. **151** Brian Yale (l), David Carpanini (r). **154** Ian Simpson. **155** Stan Smith. **156** Stan Smith. **157** Tony Coombs. **165** Ray Mutimer. **166** Leonard Leone. **170** Kay Gallwey. **172** Elizabeth Moore. **175** Vera Curnow. **177** Viv Foster. **179** Elizabeth Moore (l), Kay Gallwey (r). **181** Vera Curnow (b). **182** Vera Curnow. **183** Carl Melegari (t), John Skeaping (b). **186** Rosalind Cuthbert. **187** Valerie Wiffen. **196** Kay Gallwey (b). **201** Ray Mutimer. **202** Kay Gallwey. **203** Catherine Denvir (l), Sally Strand (r). **205** David Cuthbert. **207** Paul Bartlett (t), Bruce Cody (b). **208** Joyce Zavorska. **209** Gordon Bennett. **210** Arthur Maderson. **212** Vera Curnow. **214** Beverly Ferguson Deevy. **215** Vera Curnow. **216** Vera Curnow. **219** David Ferry (t), Pip Carpenter (b).

Although every effort has been made to acknowledge all copyright holders, we apologize if any omissions have been made.